Petal Madness
Adult Coloring Book

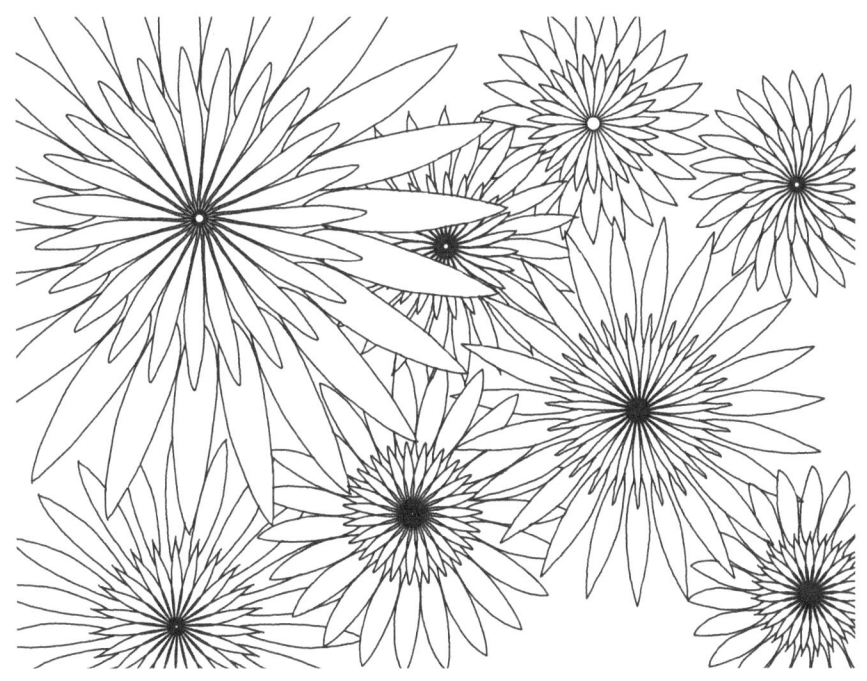

by Terry McClary

Copyright © 2016 Terry McClary

All rights reserved. This book or any portion thereof may not be reproduced or used in any manner whatsoever without the express written permission of the author/artist.

ISBN-13: 978-1539978602

ISBN-10: 1539978605

www.terrymcclary.com

Coloring Guide

The paper used in this coloring book works best with dry media such as colored pencils.

Pens and markers that dry quickly can also work well but make sure to test them on the coloring tools test page at the back of the book first.

Always place a piece of blank paper or card stock beneath the page you are working on. Not only does this prevent wet media like markers from bleeding through onto the next coloring page, it also prevents gouges and indents from dry media.

Have fun!

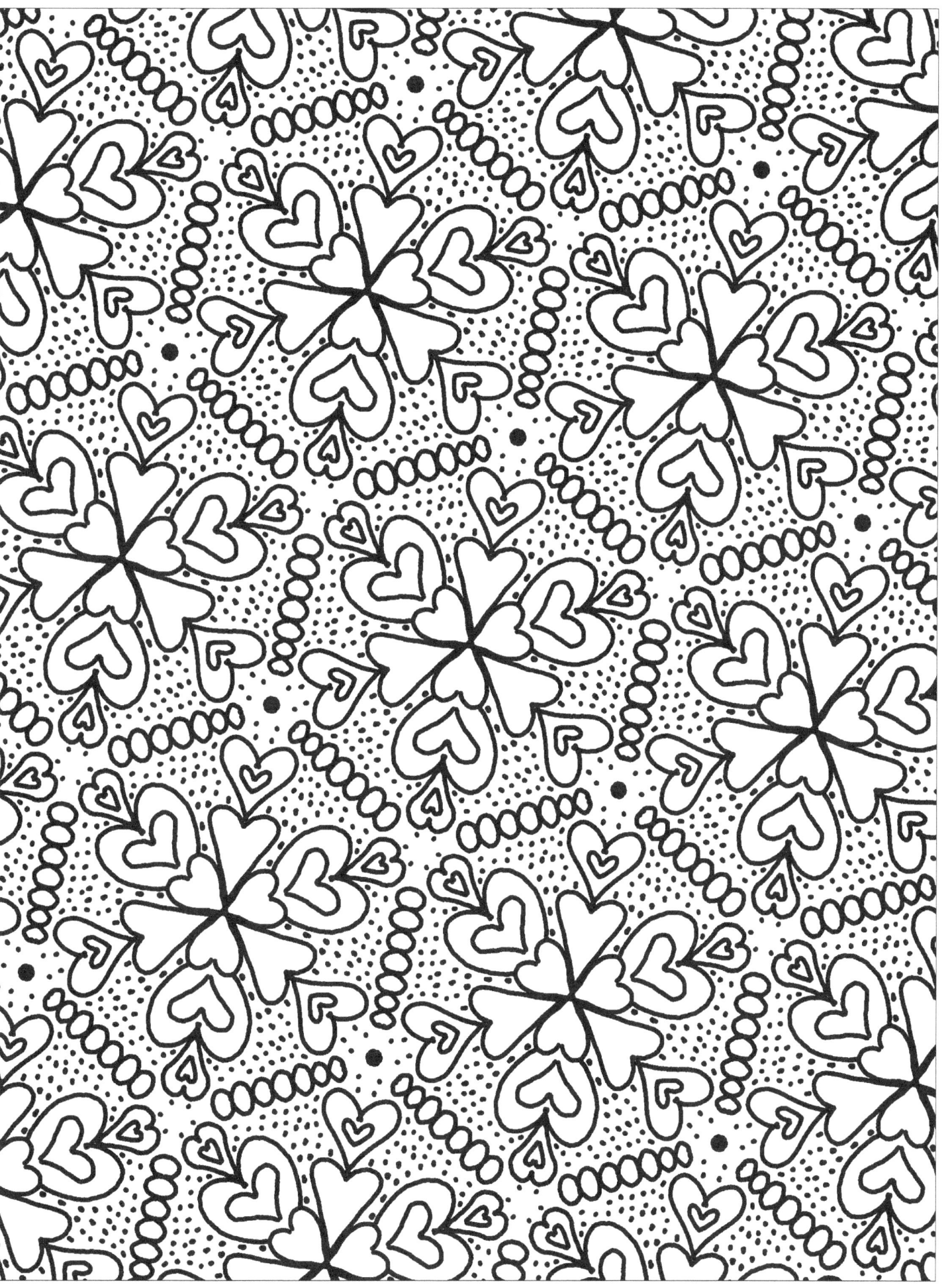

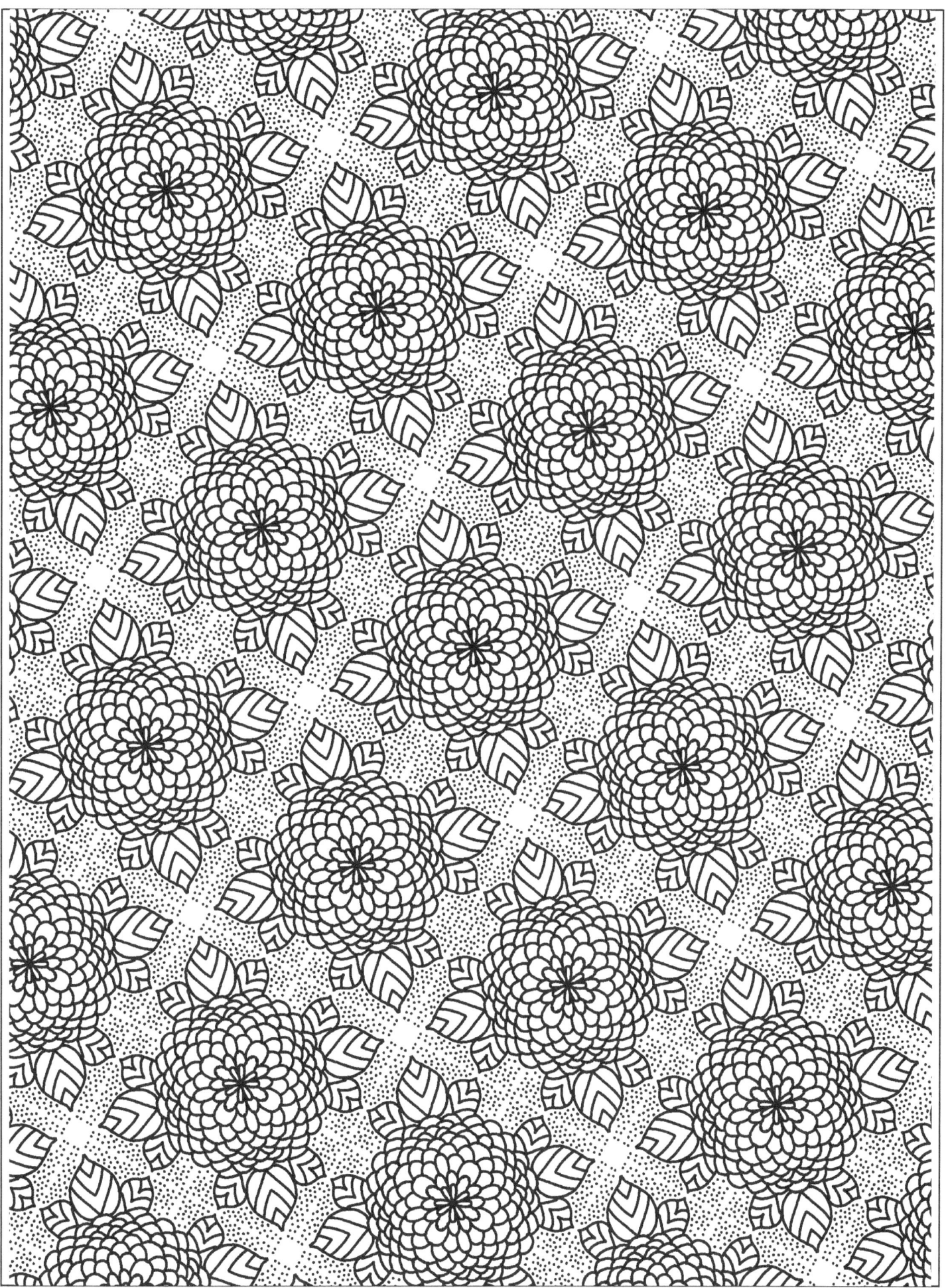

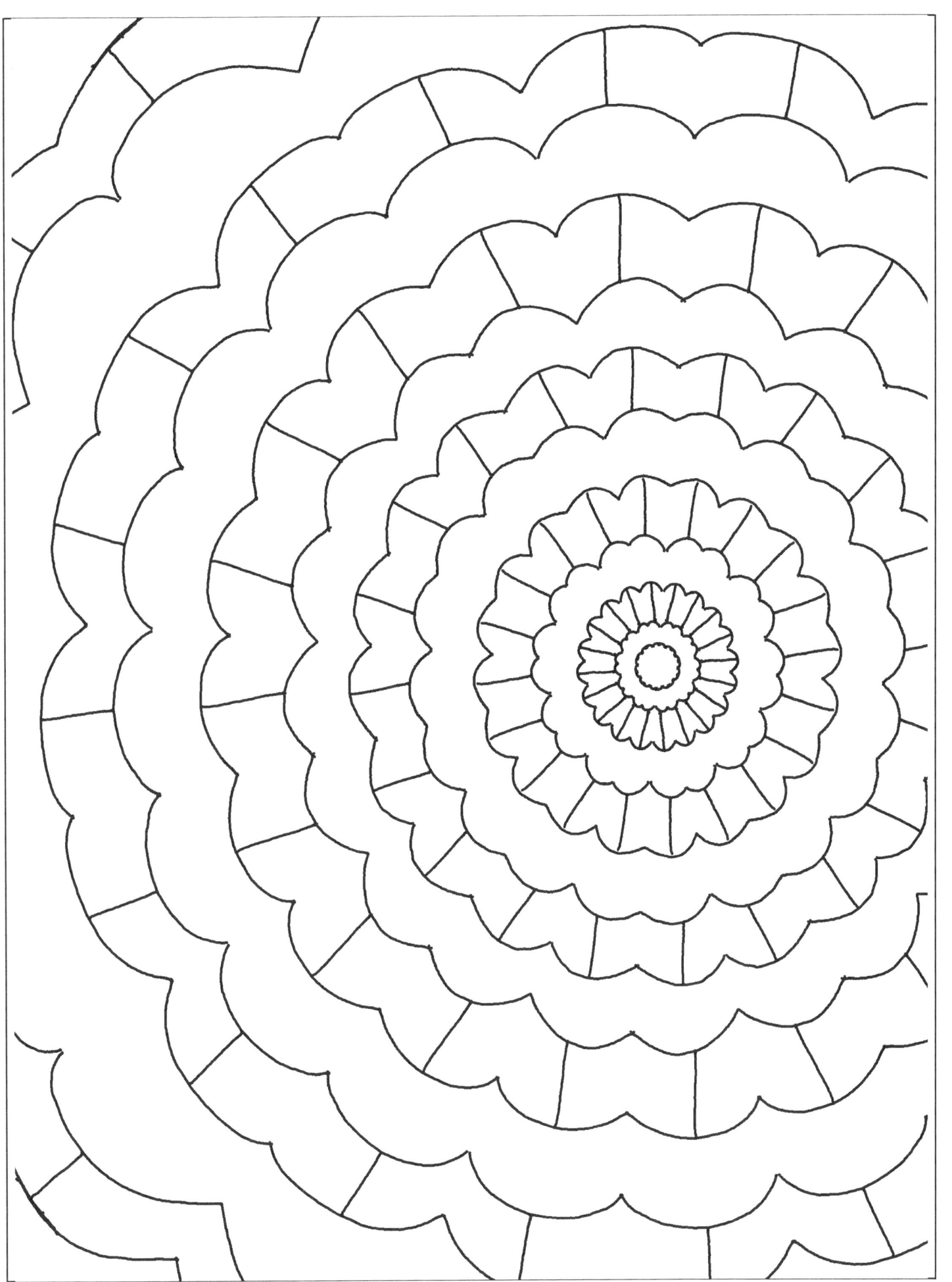

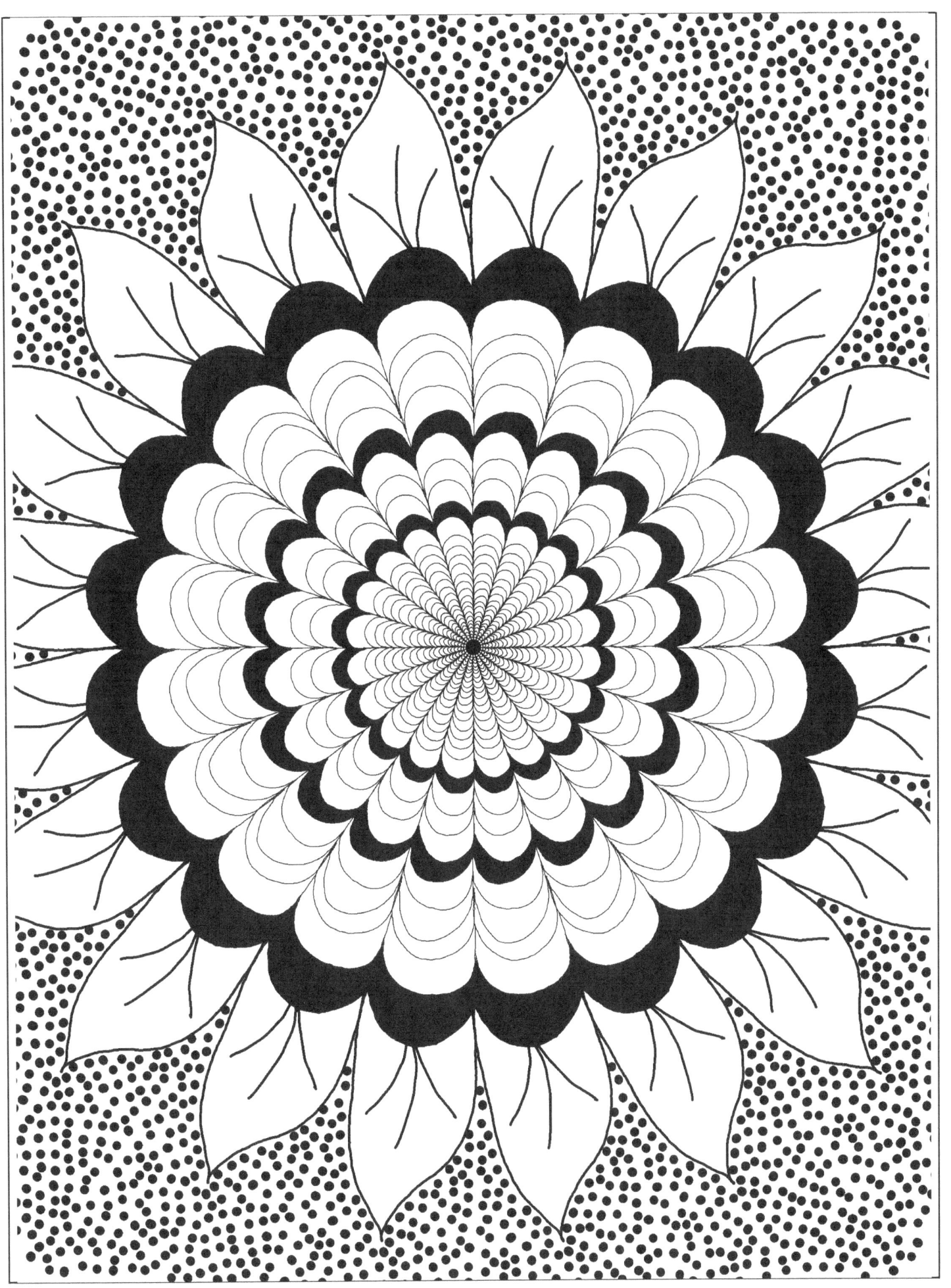

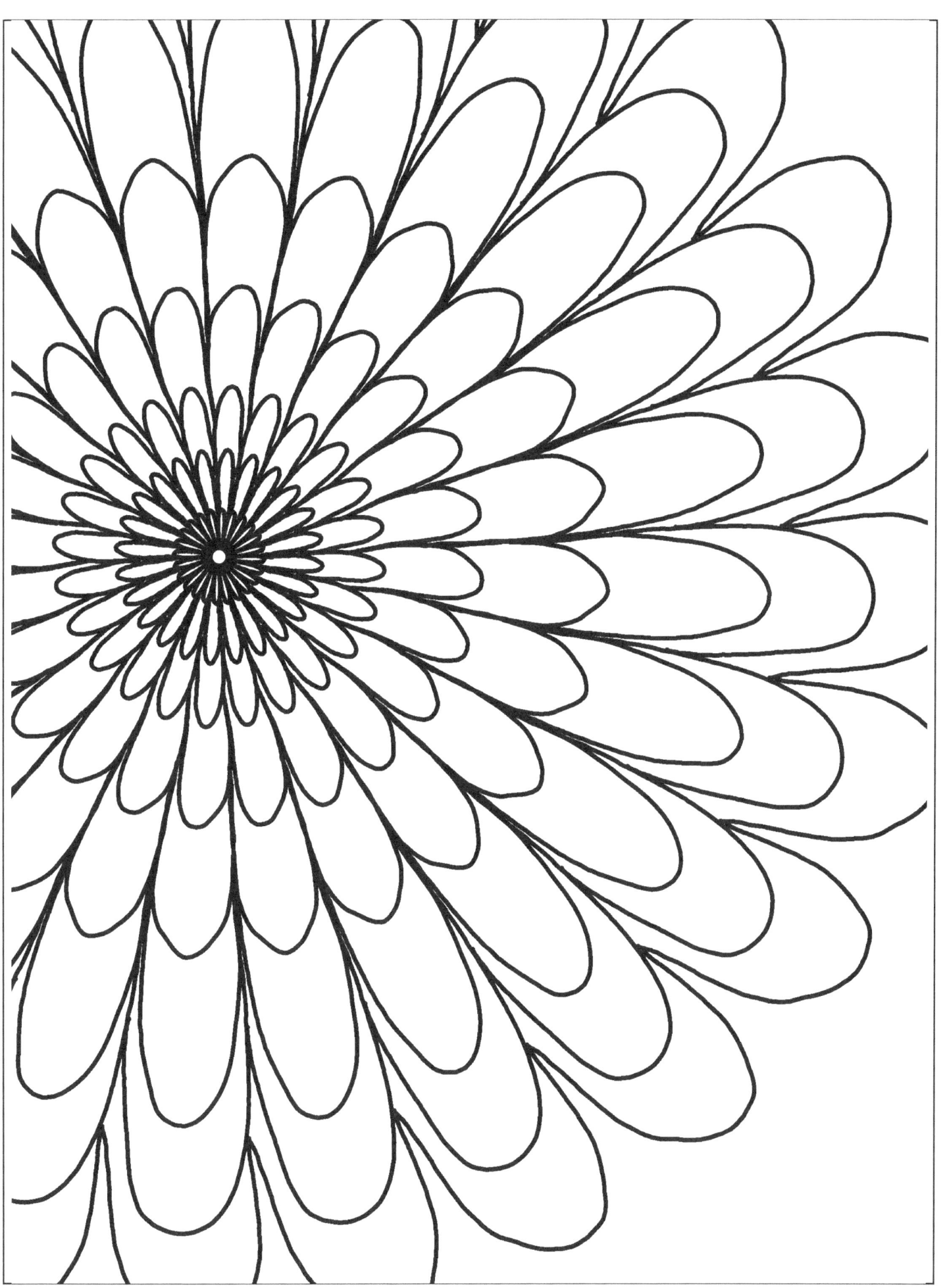

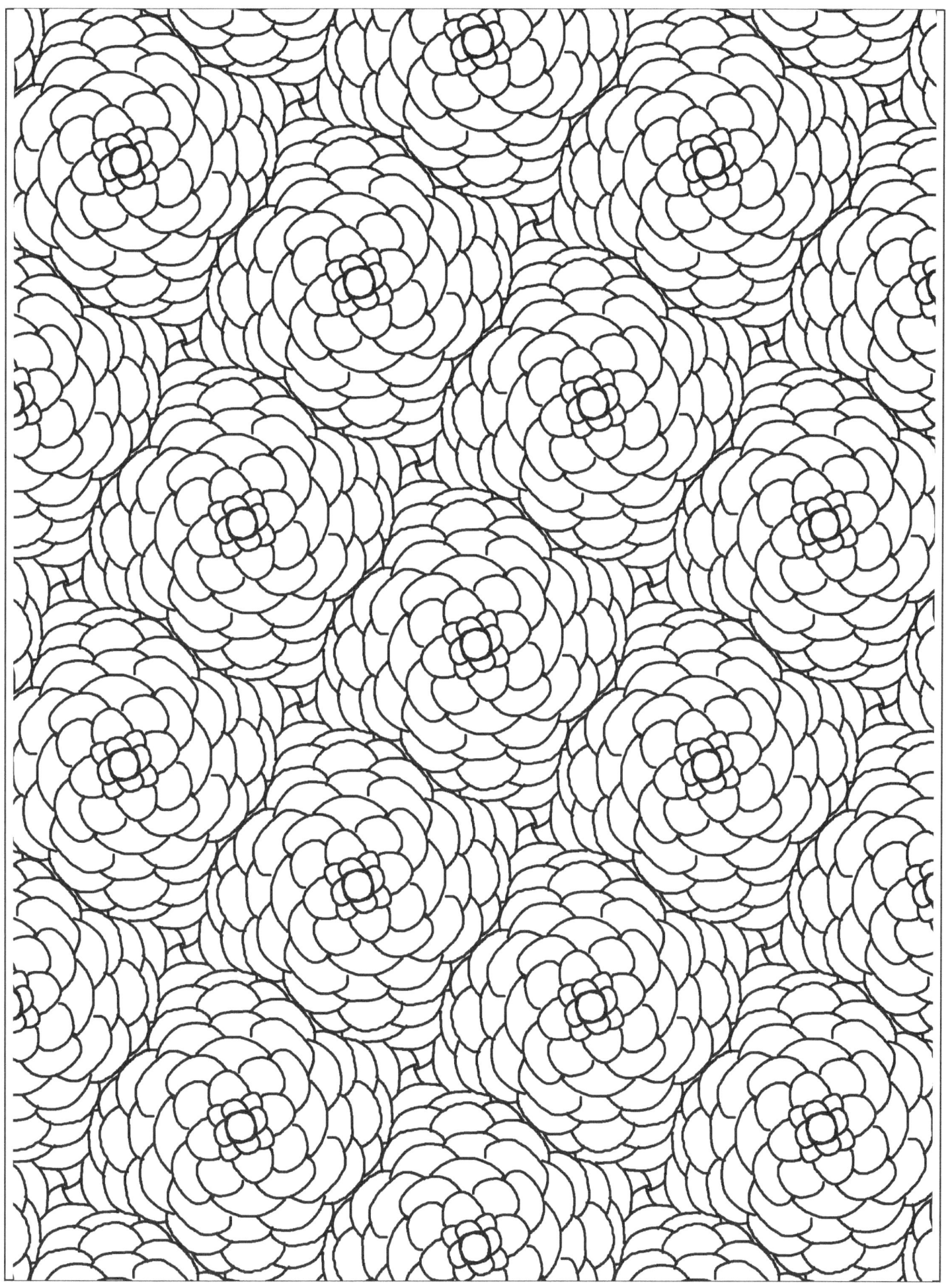

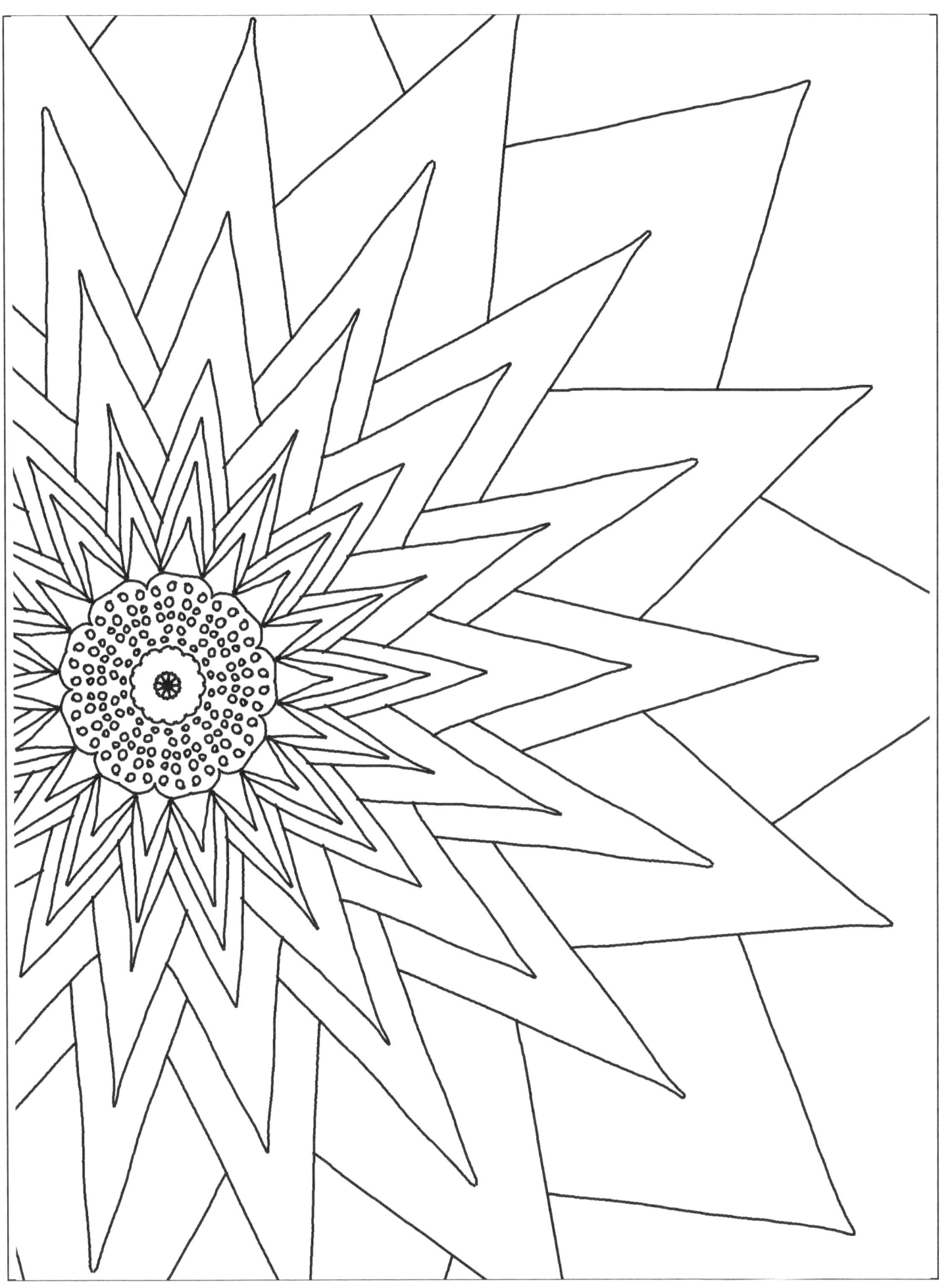

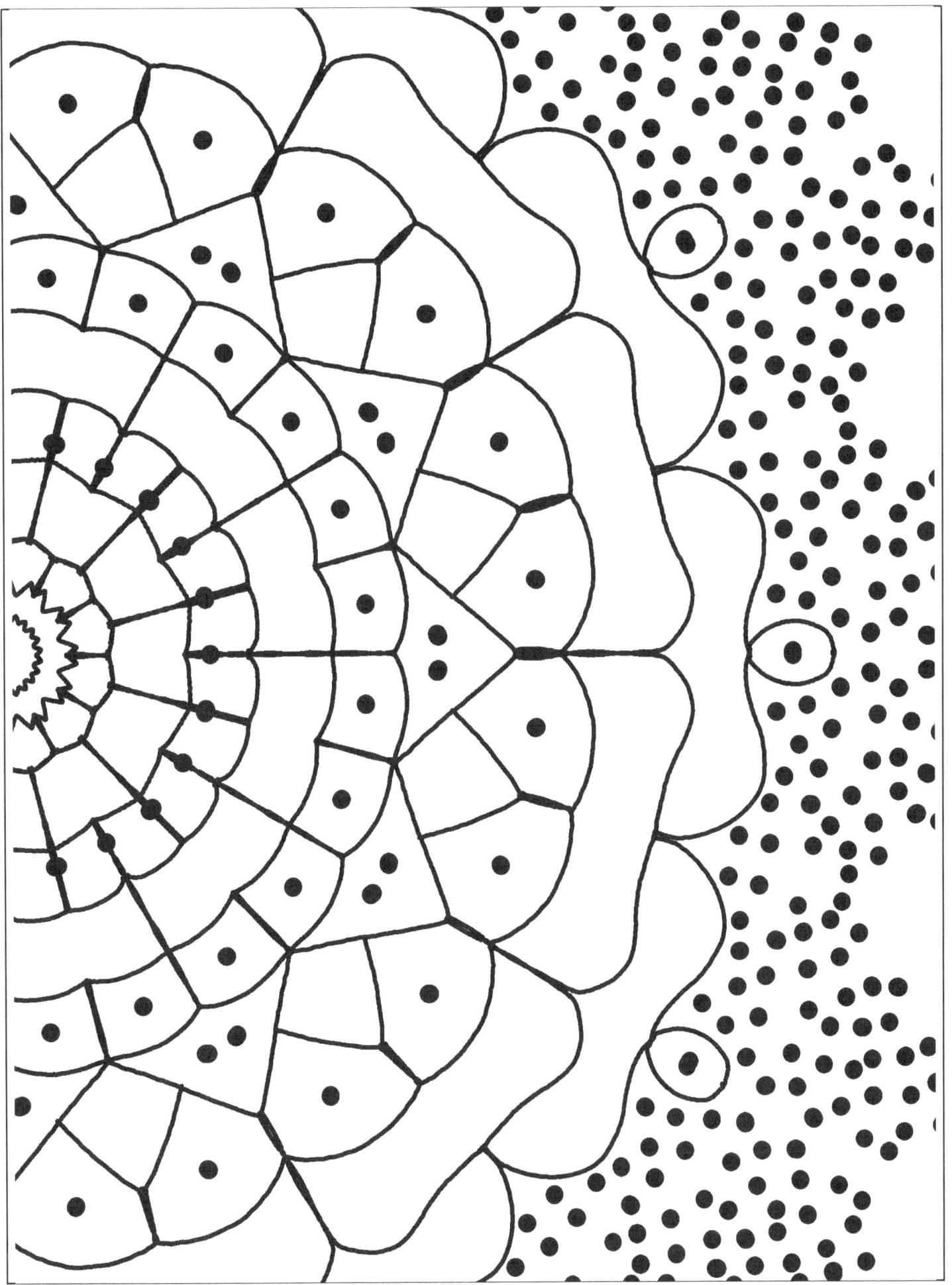

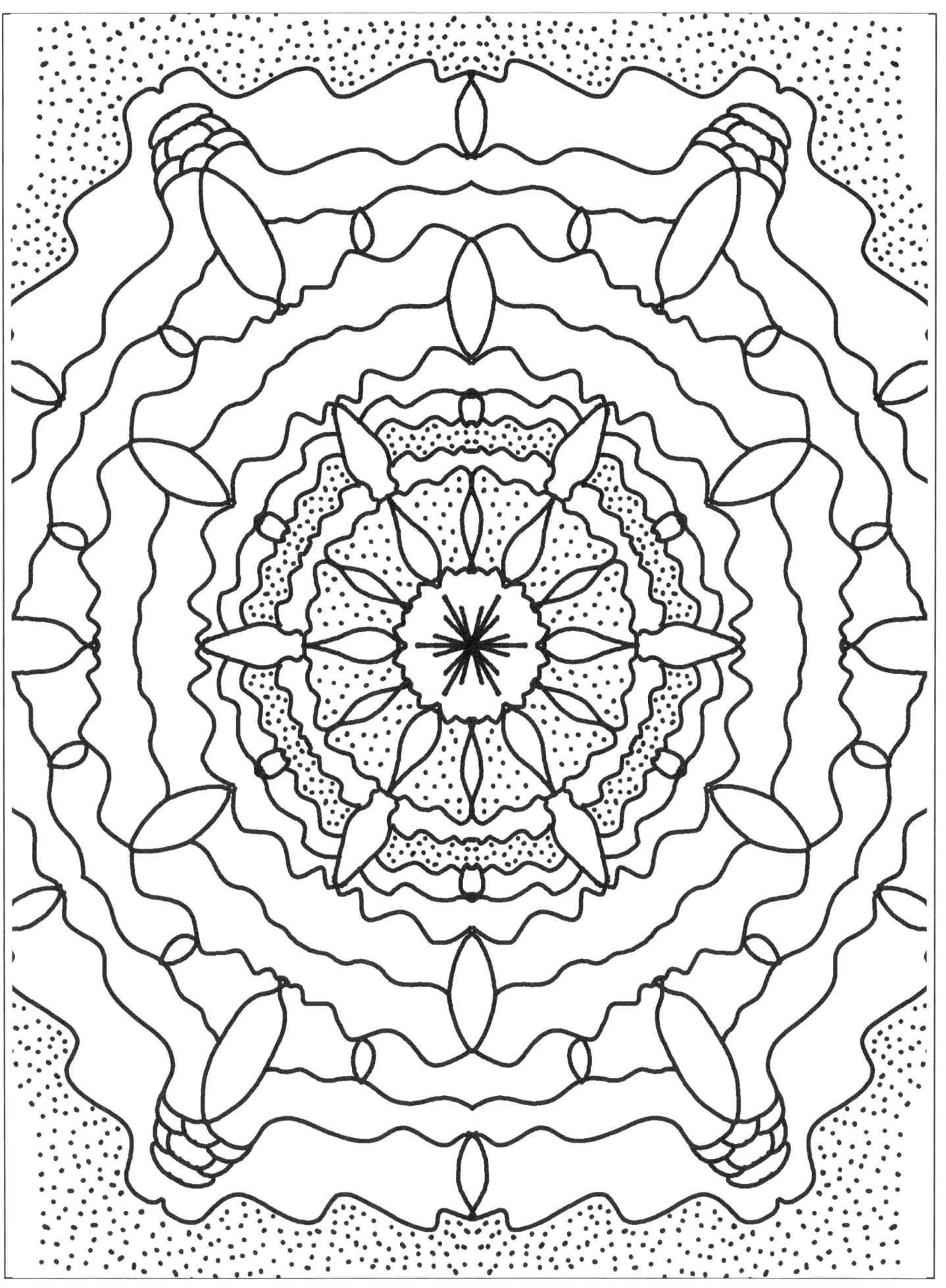

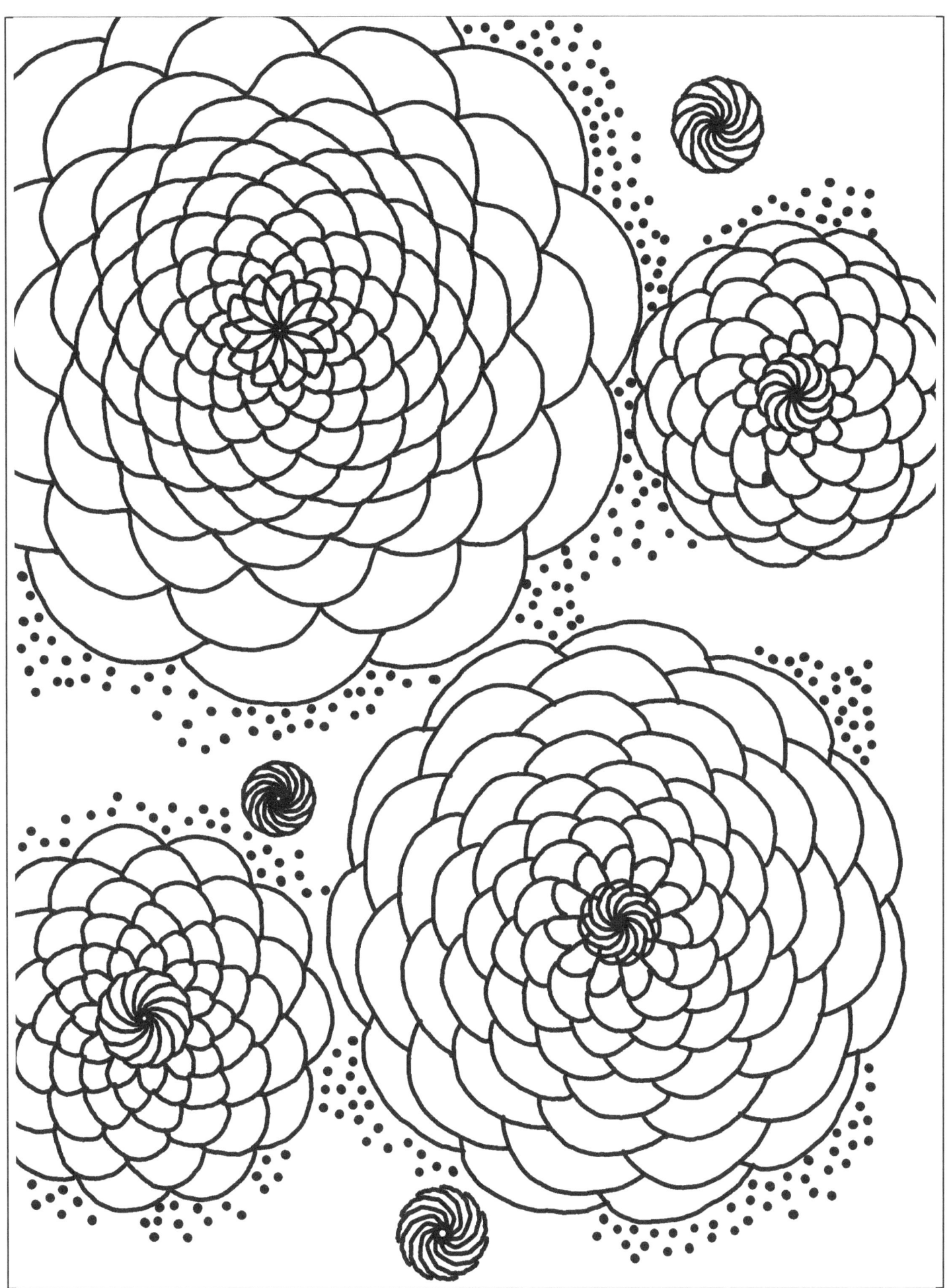

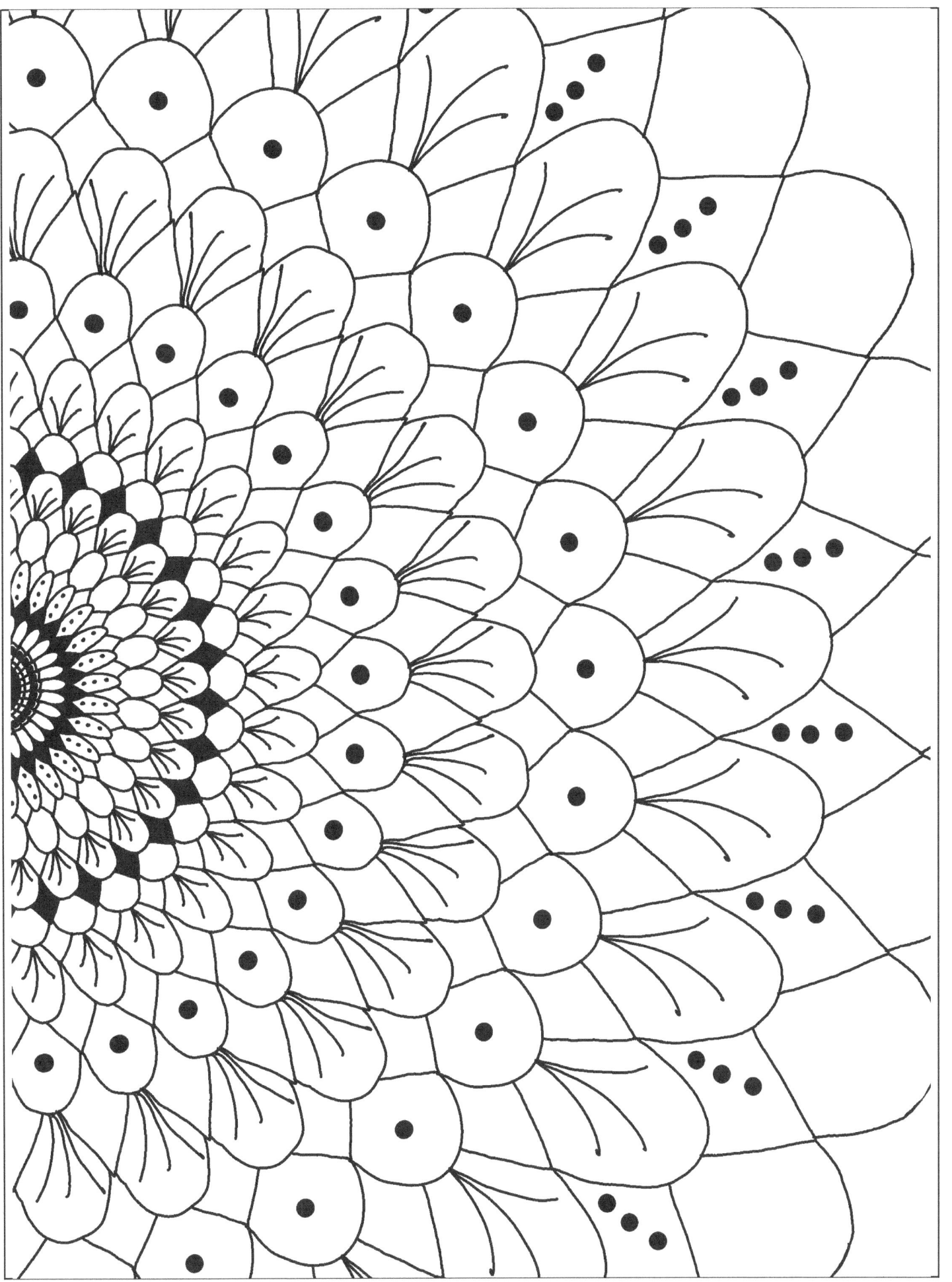

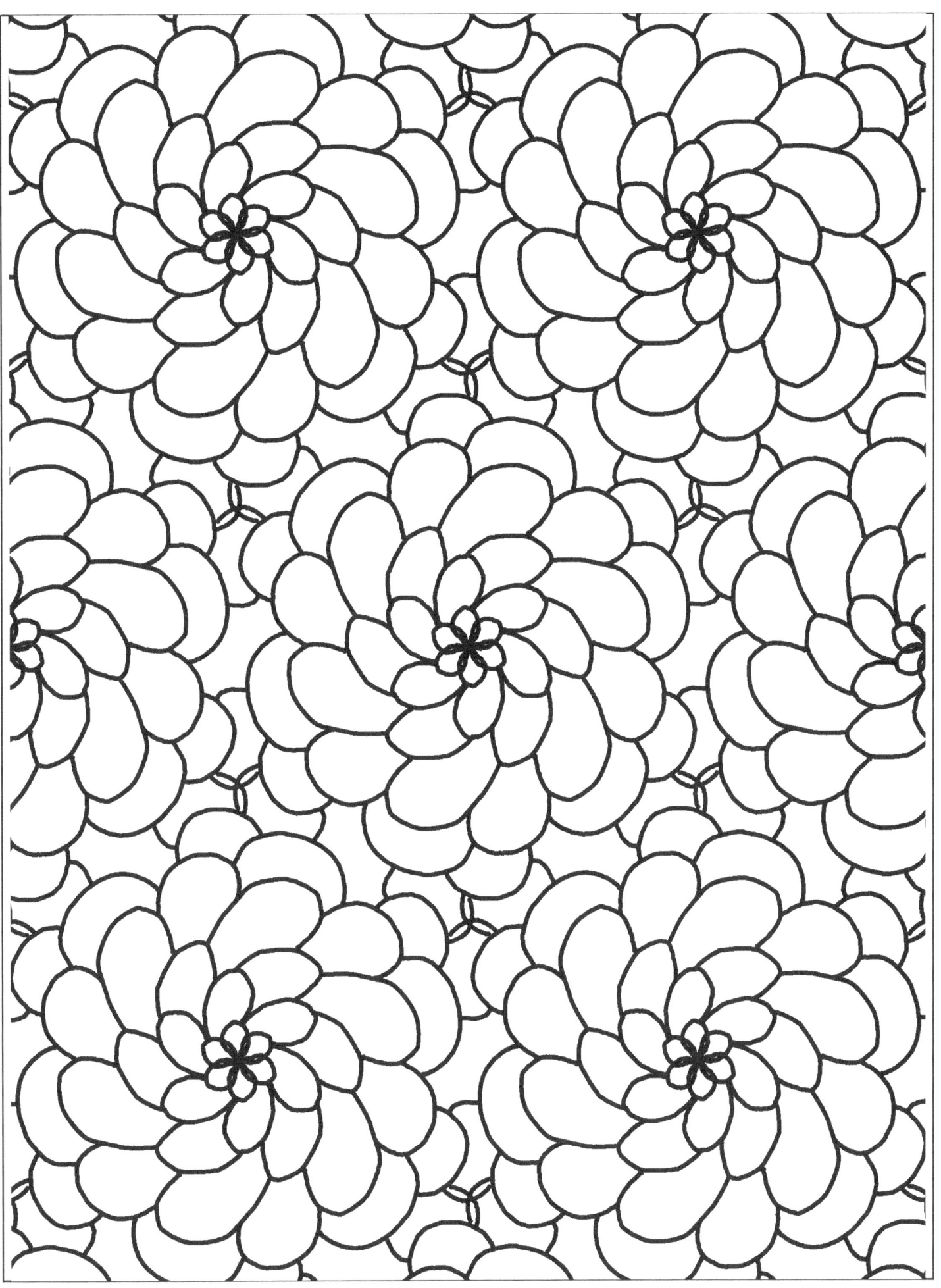

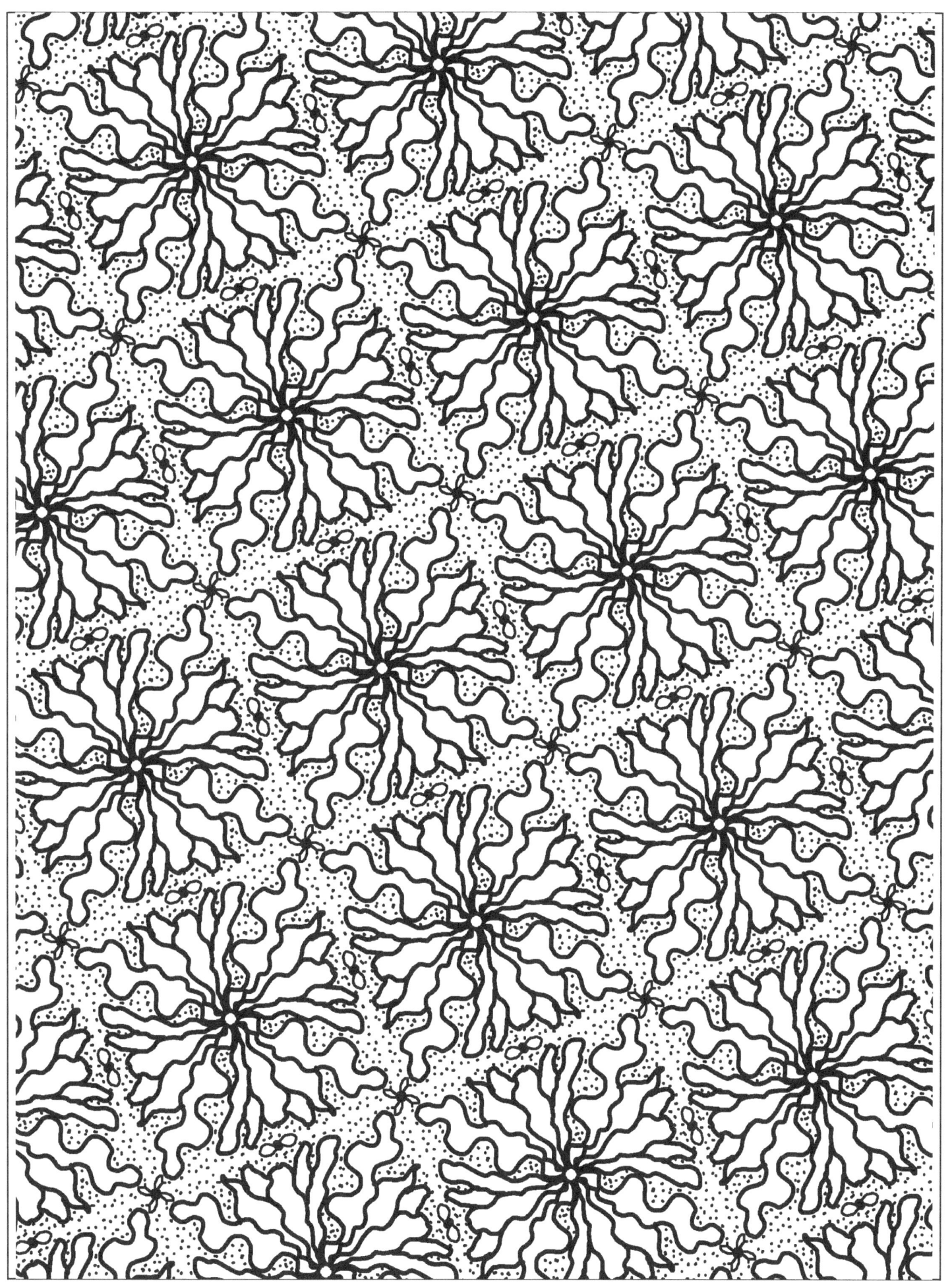

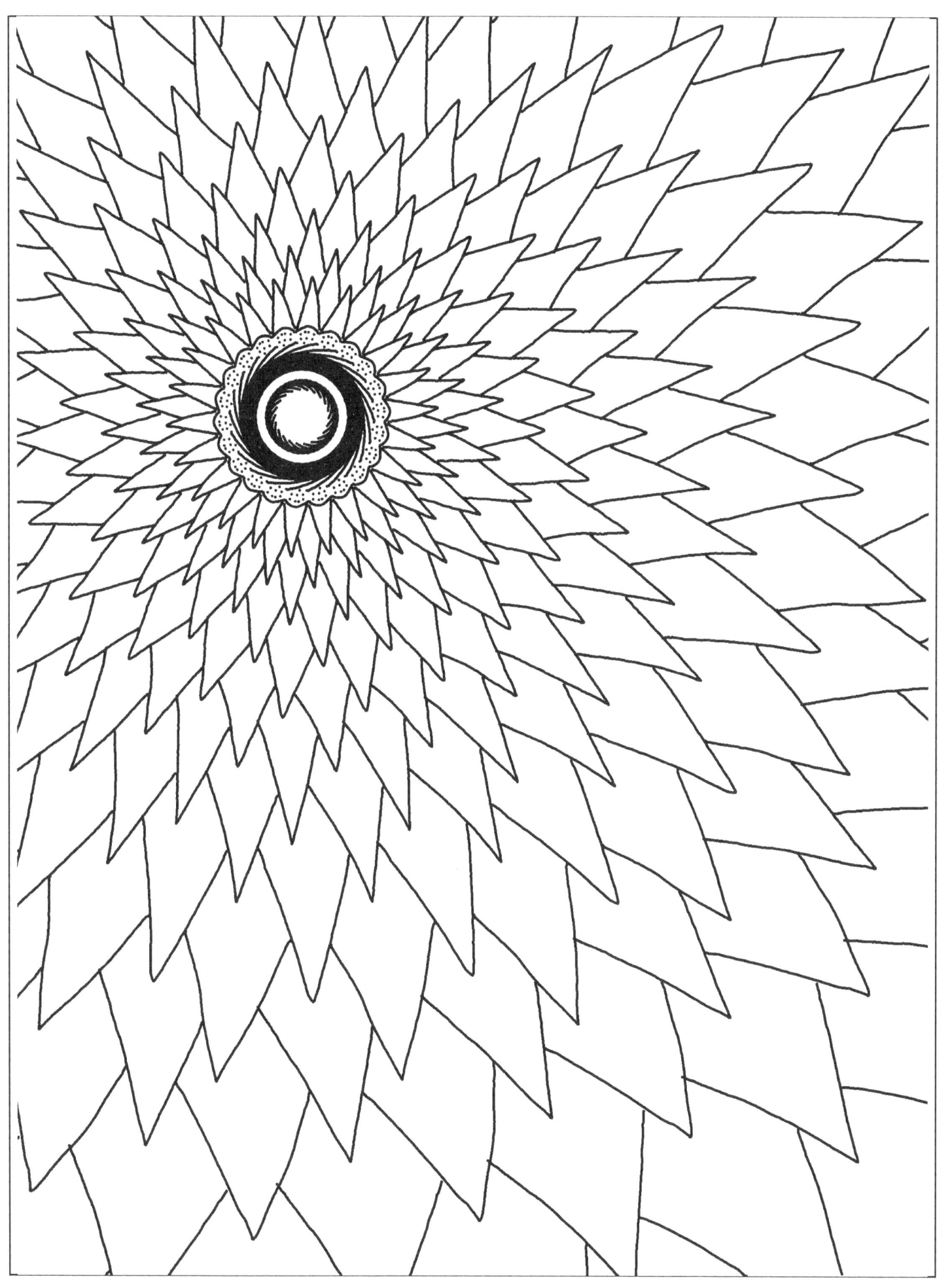

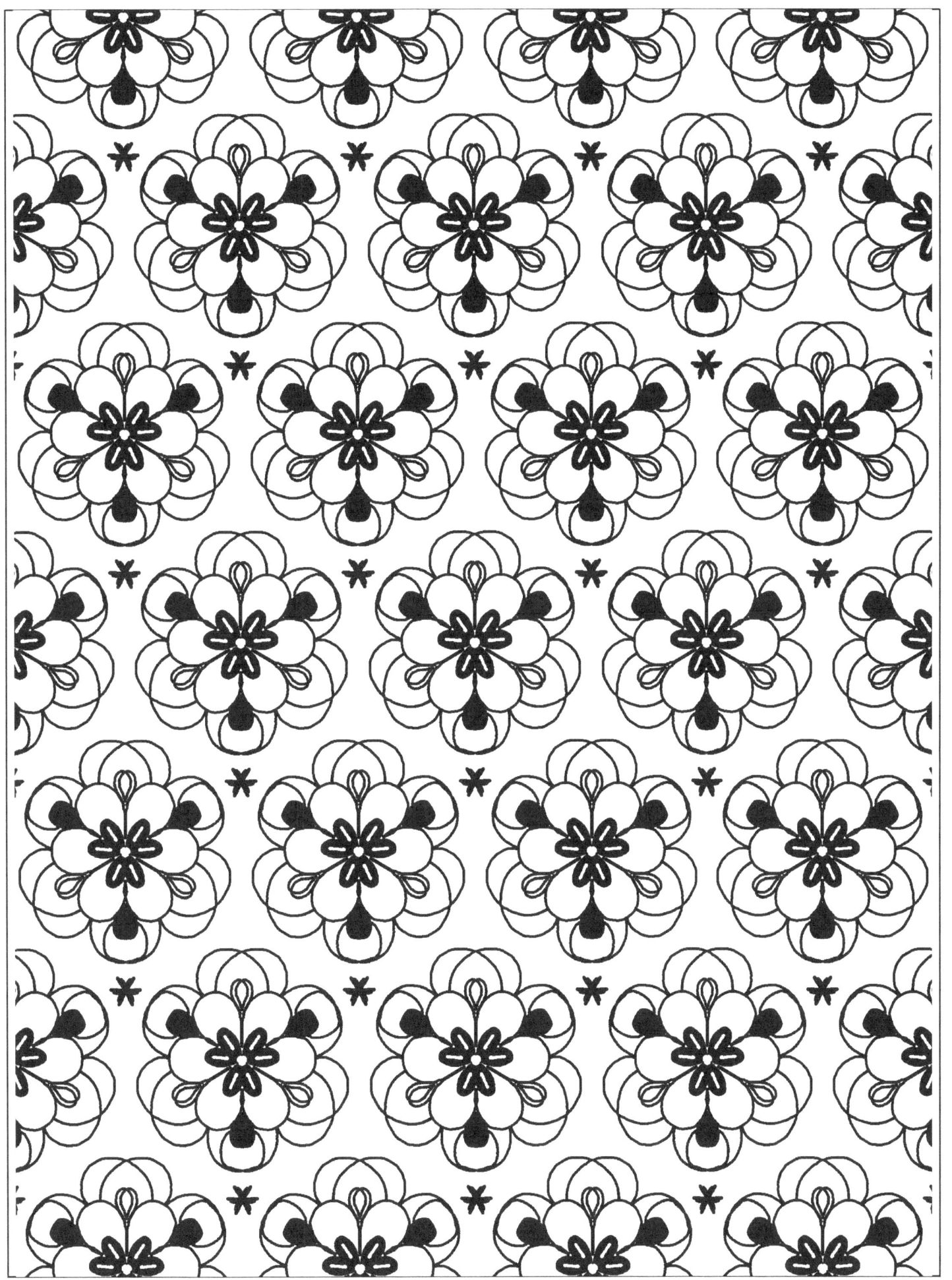

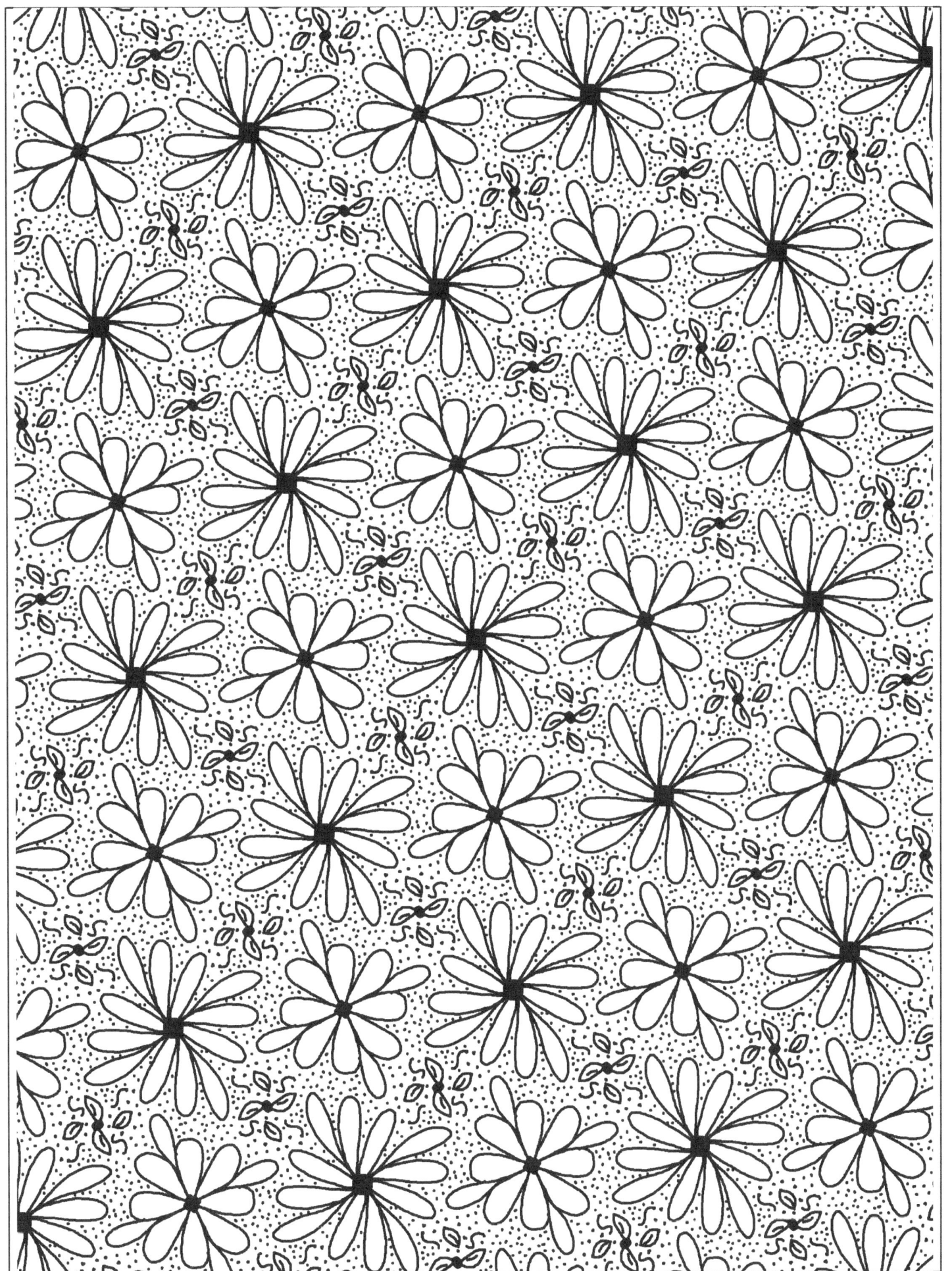

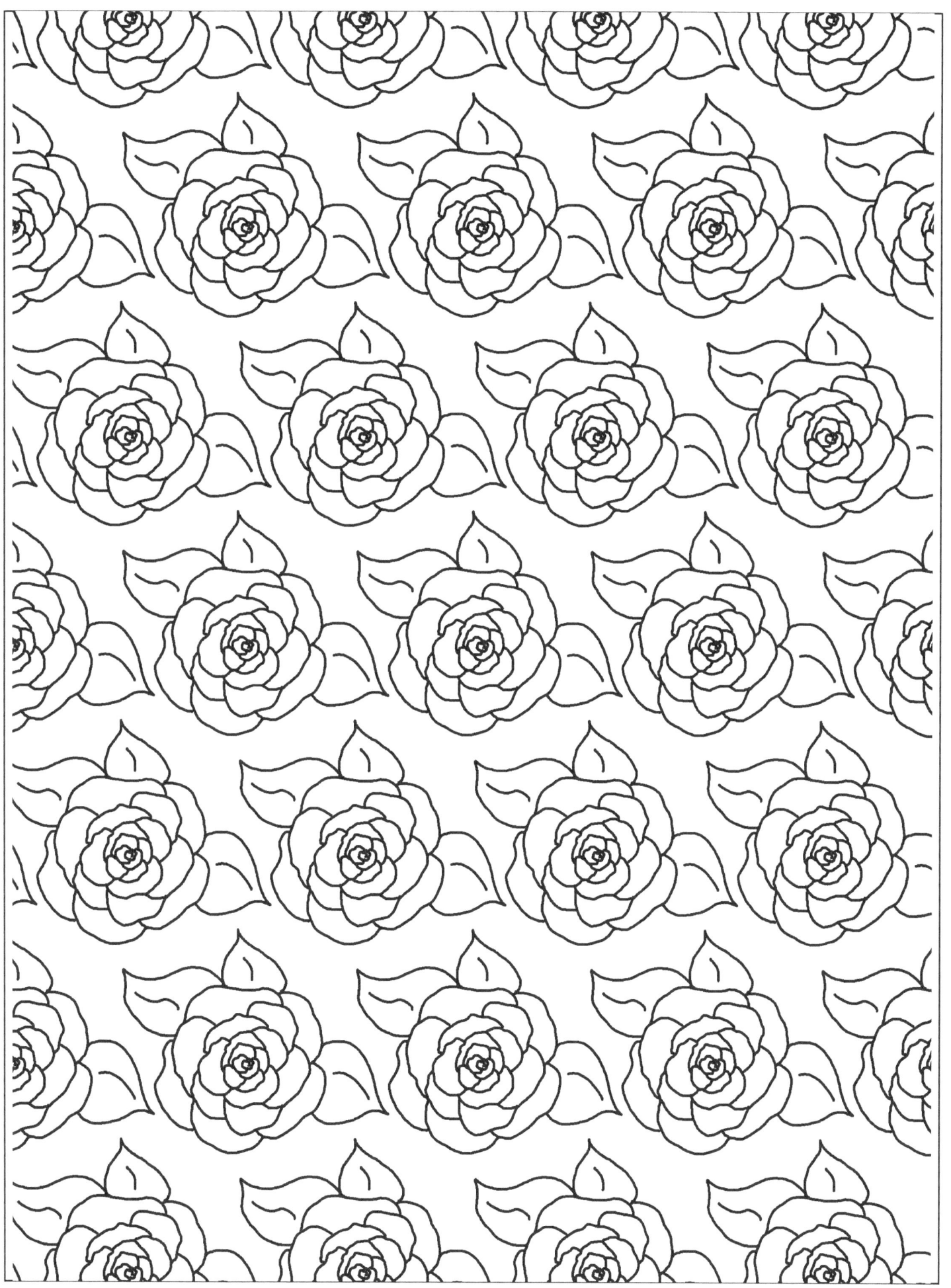

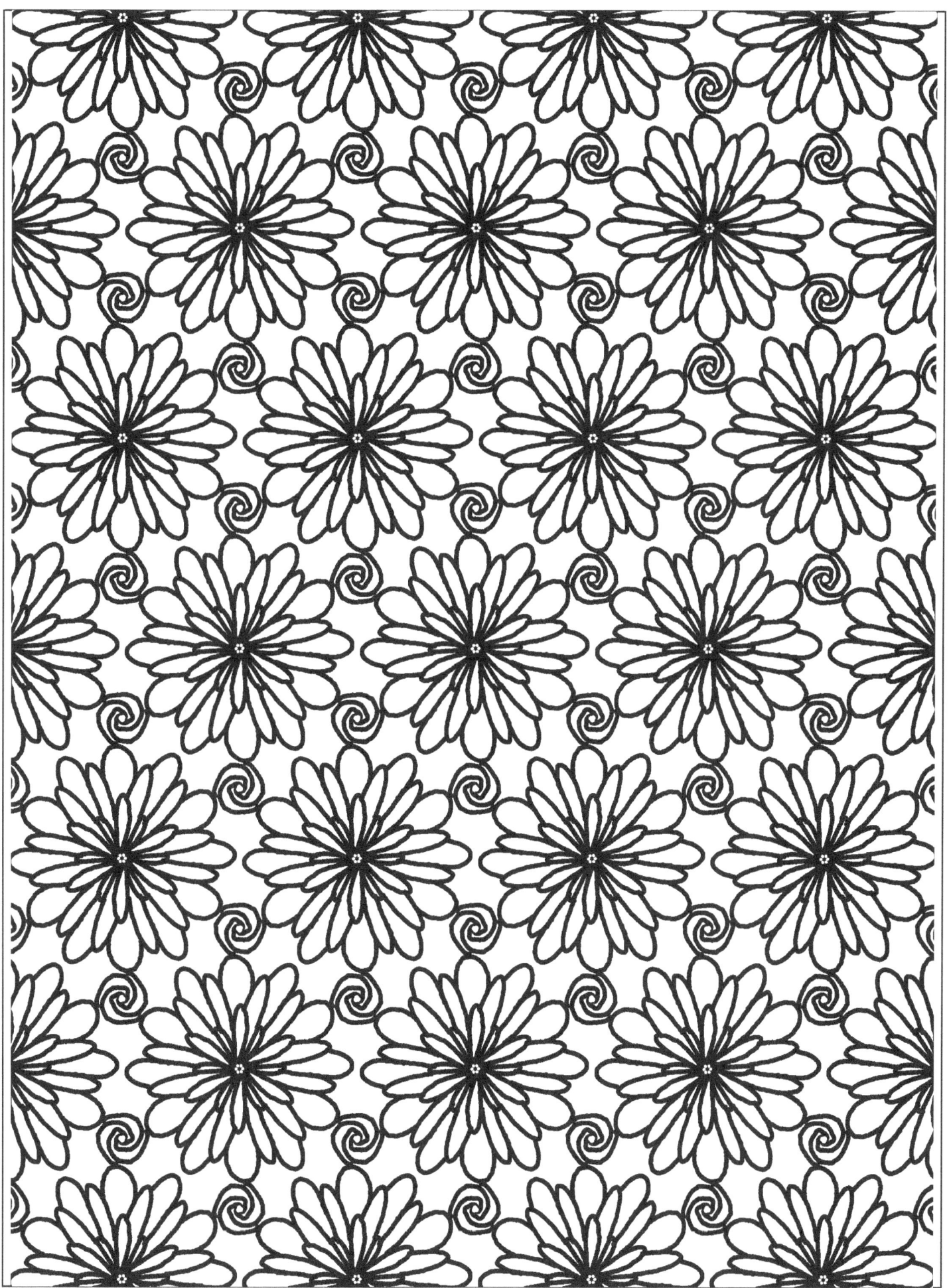

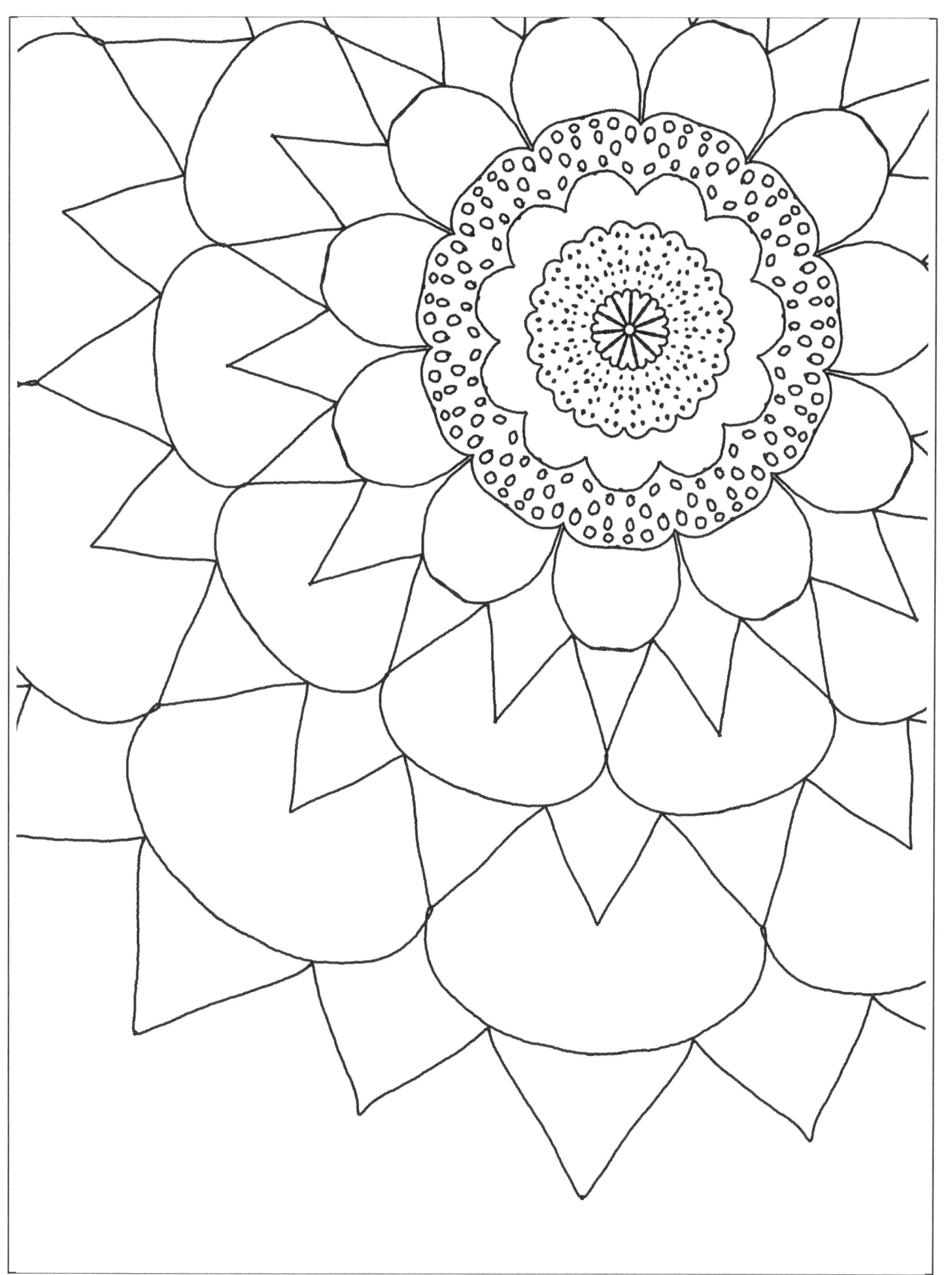

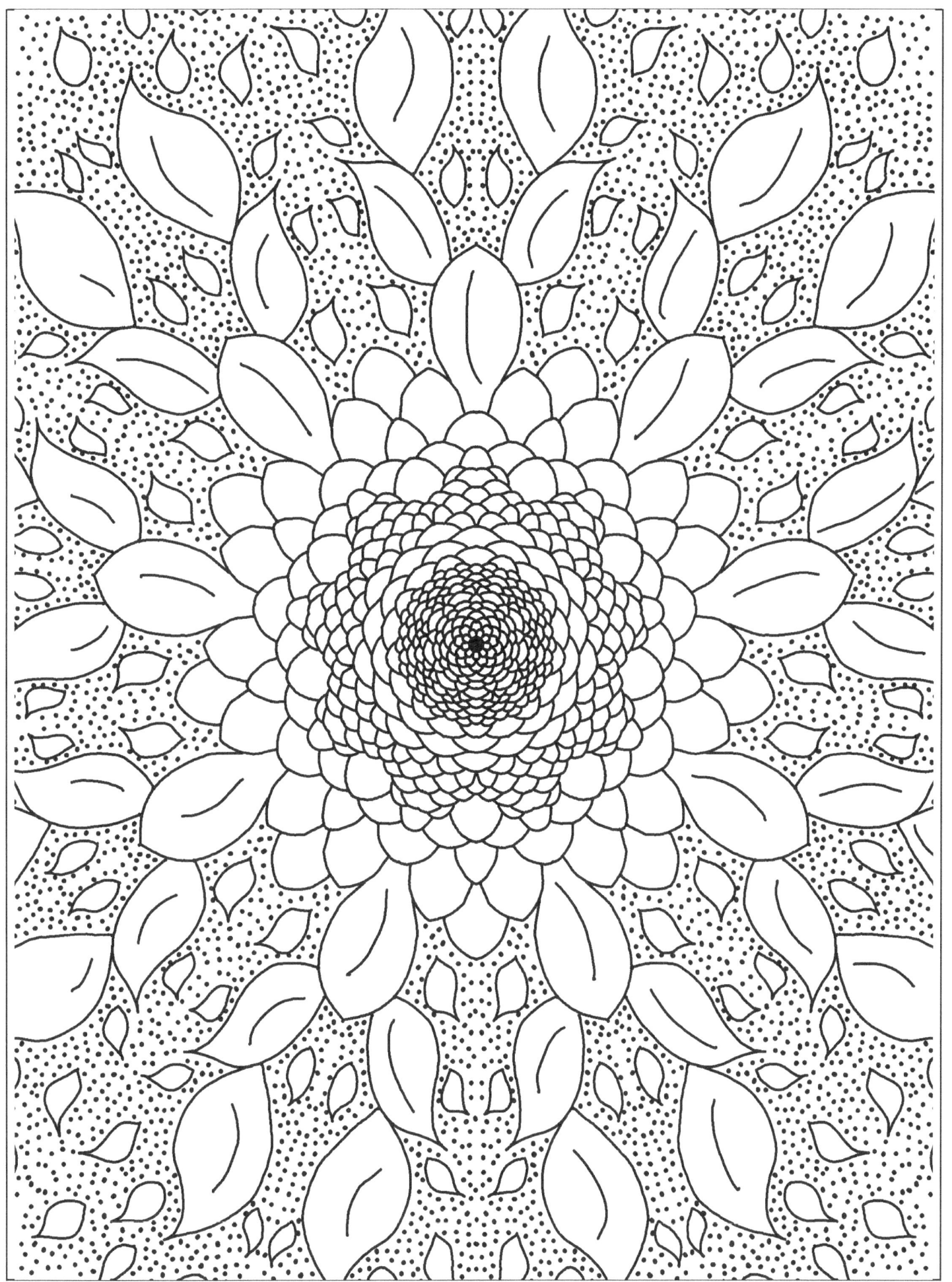

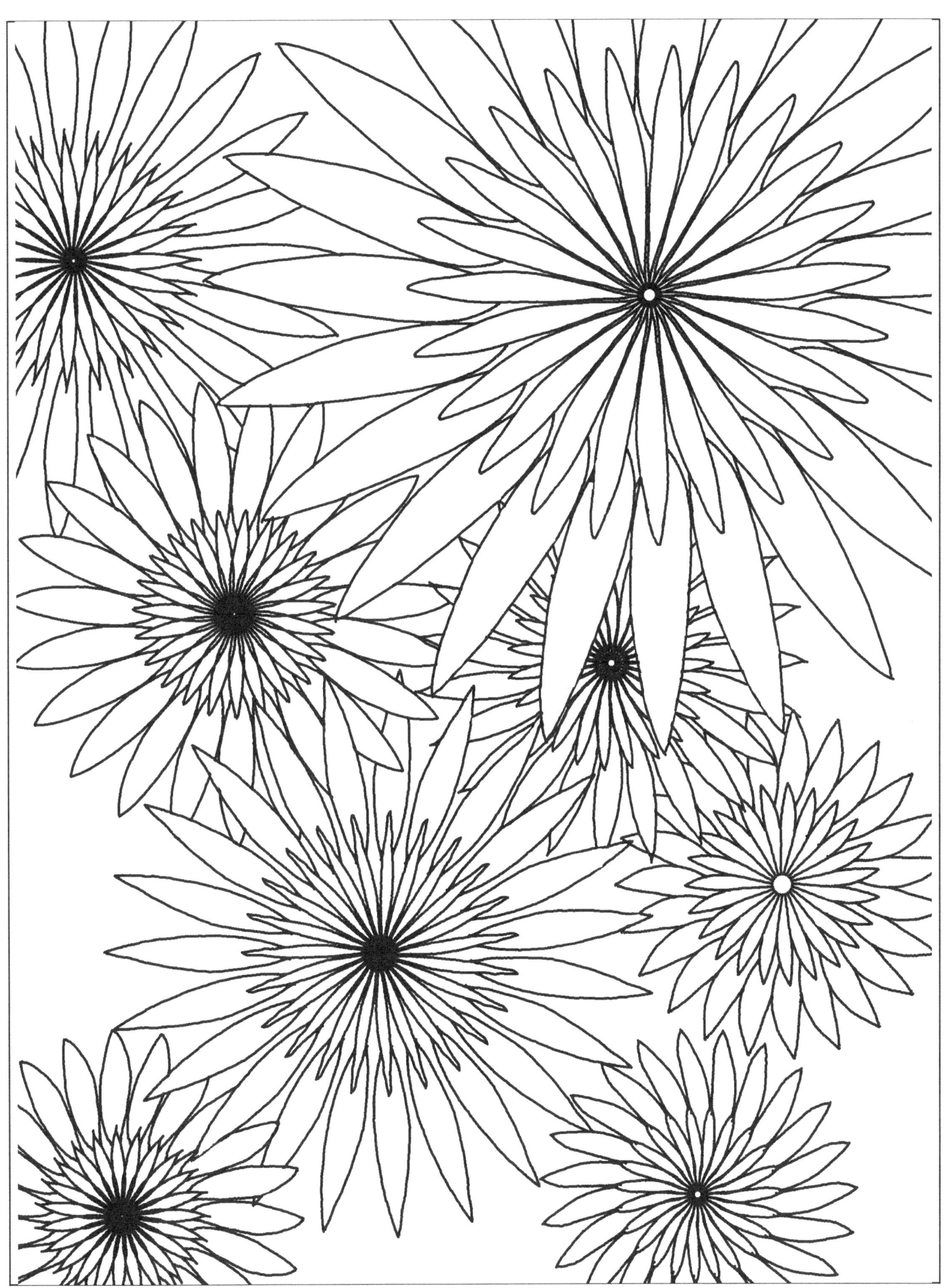

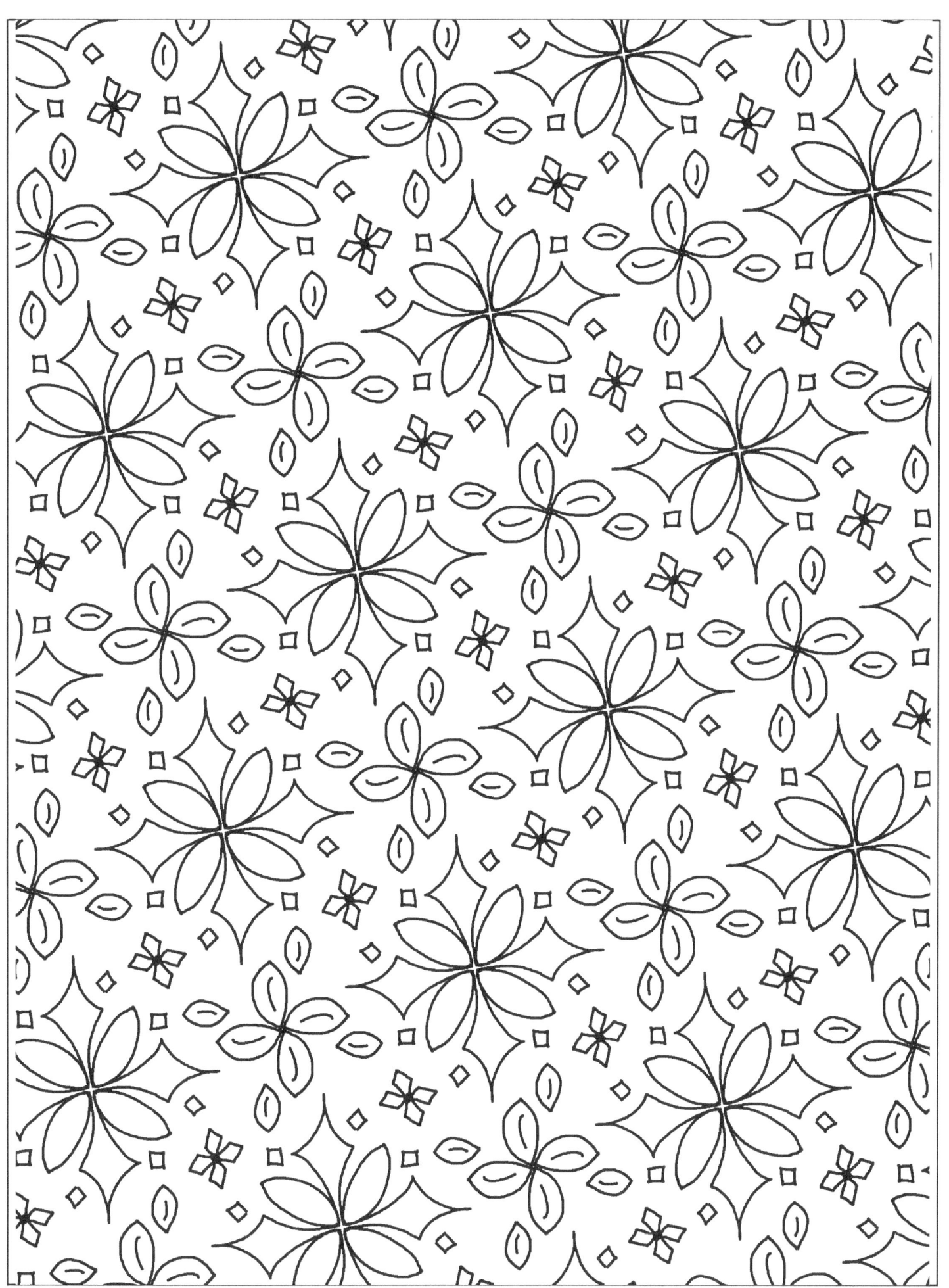

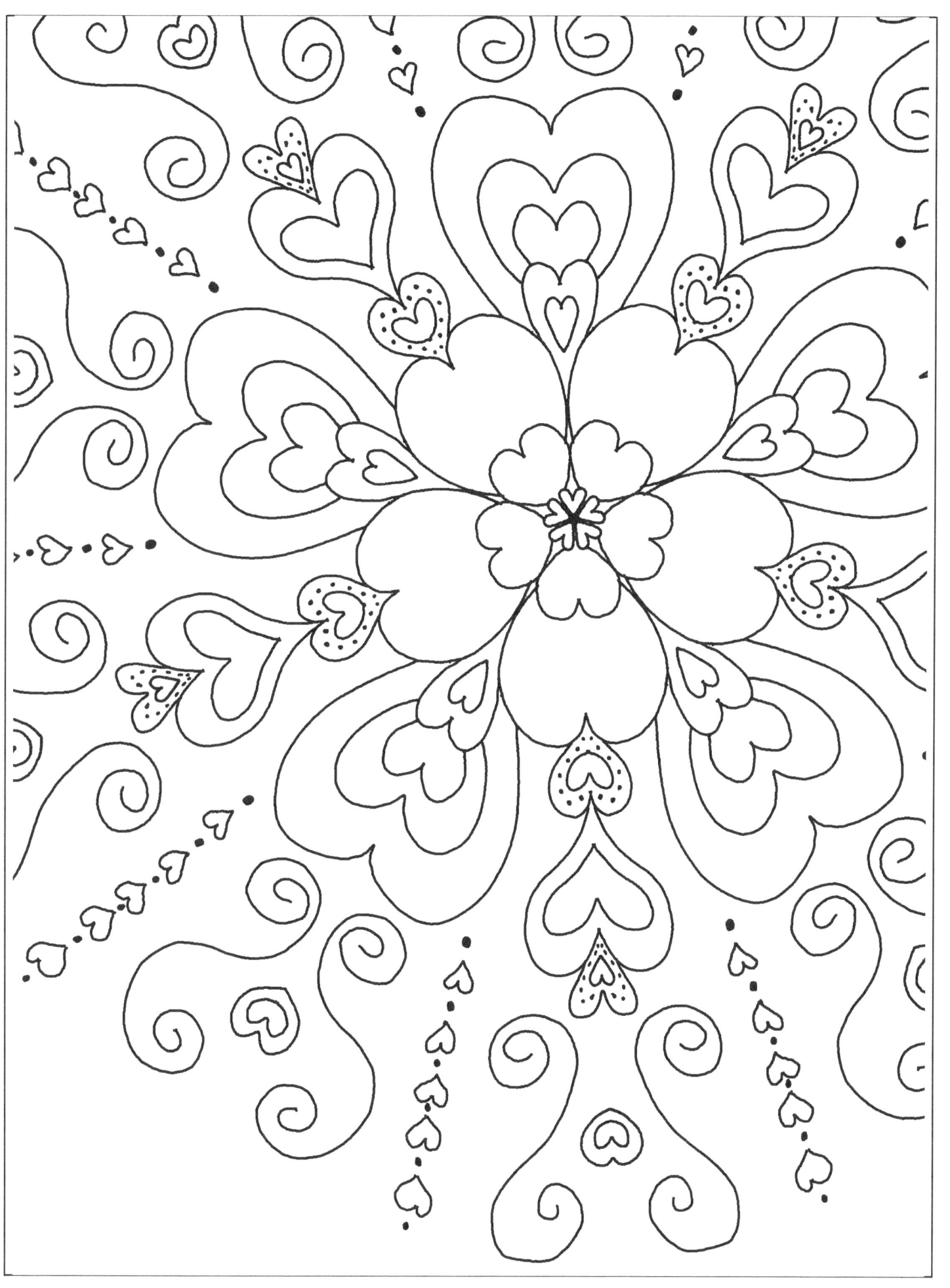

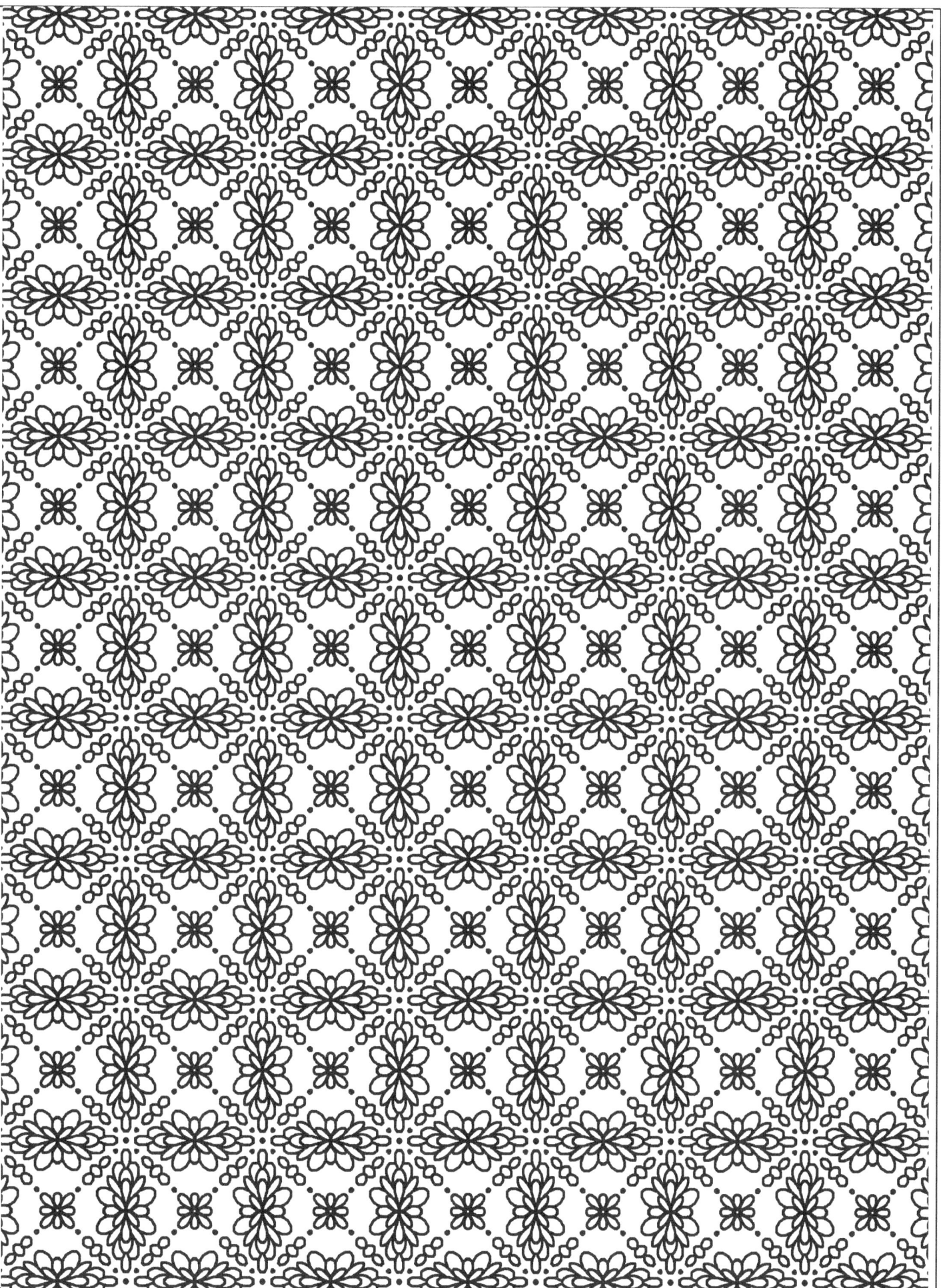

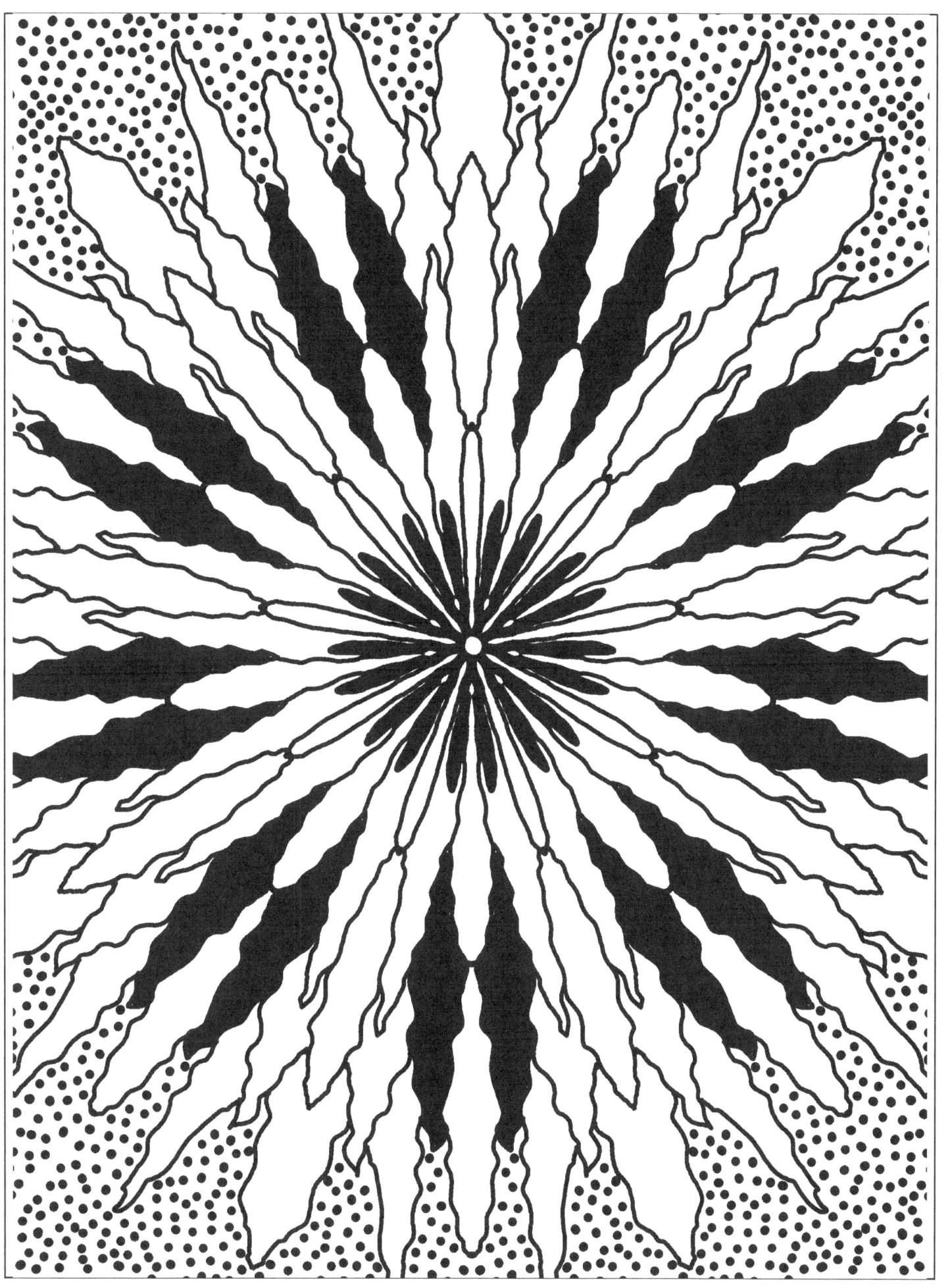

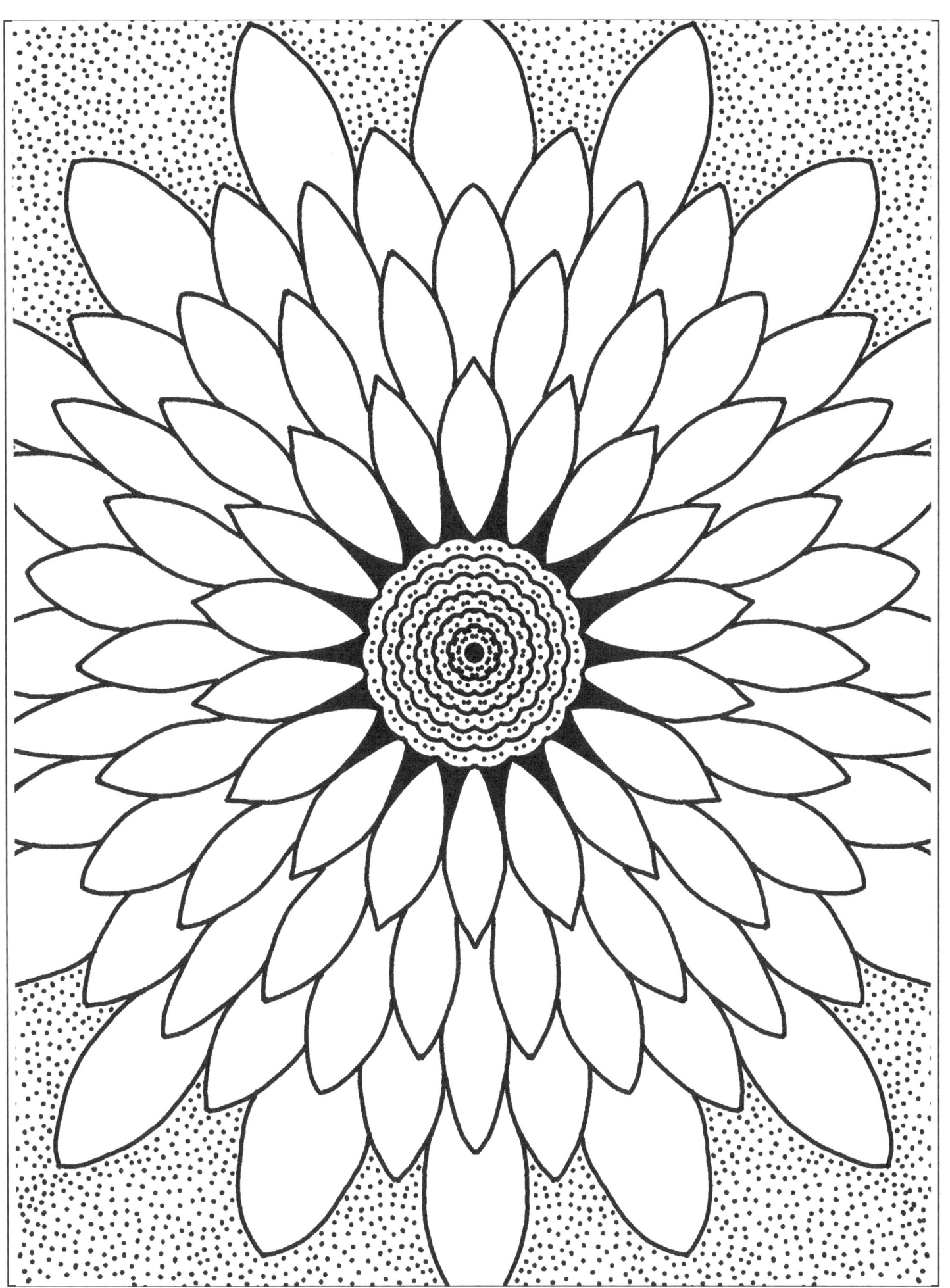

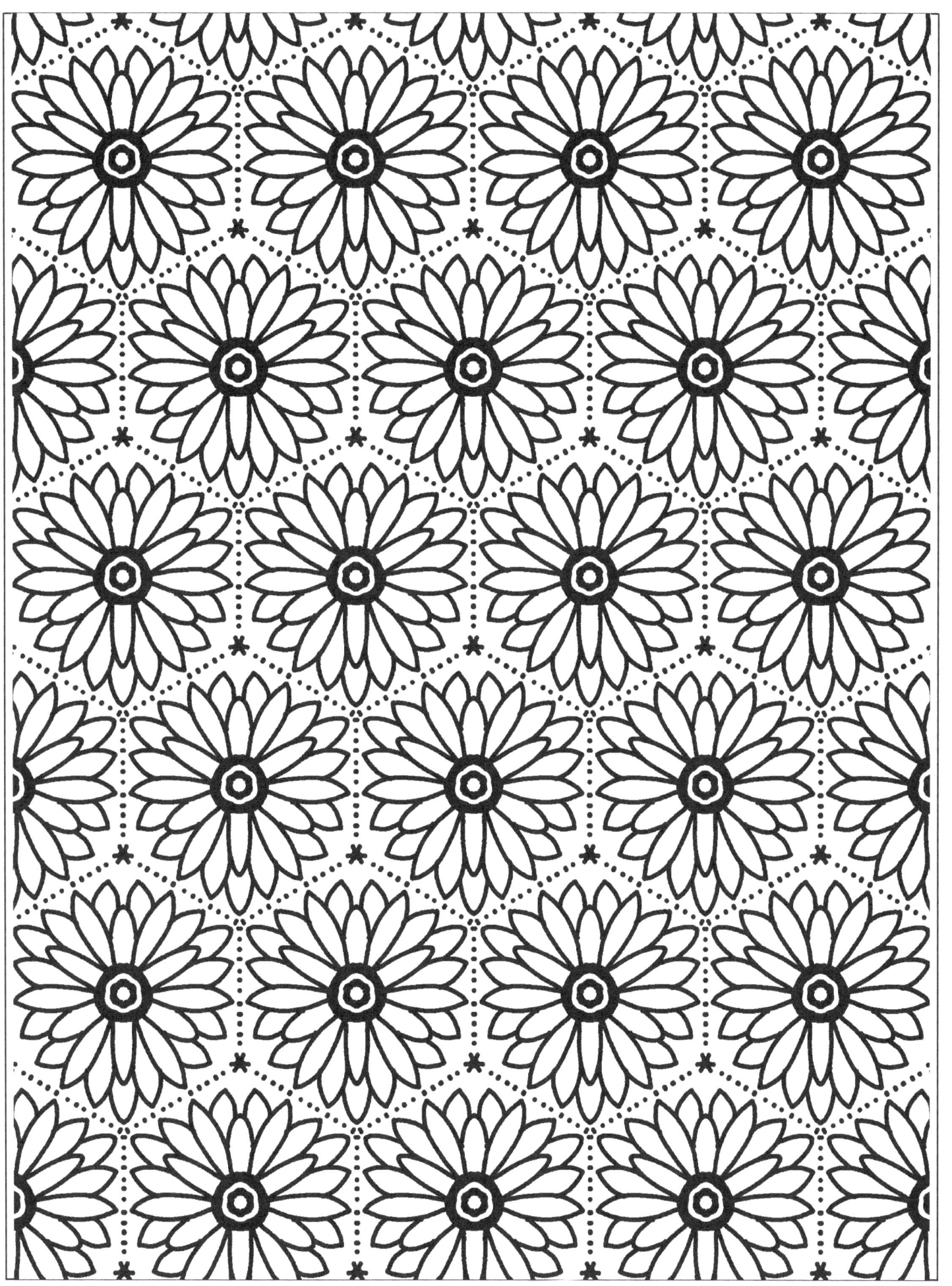

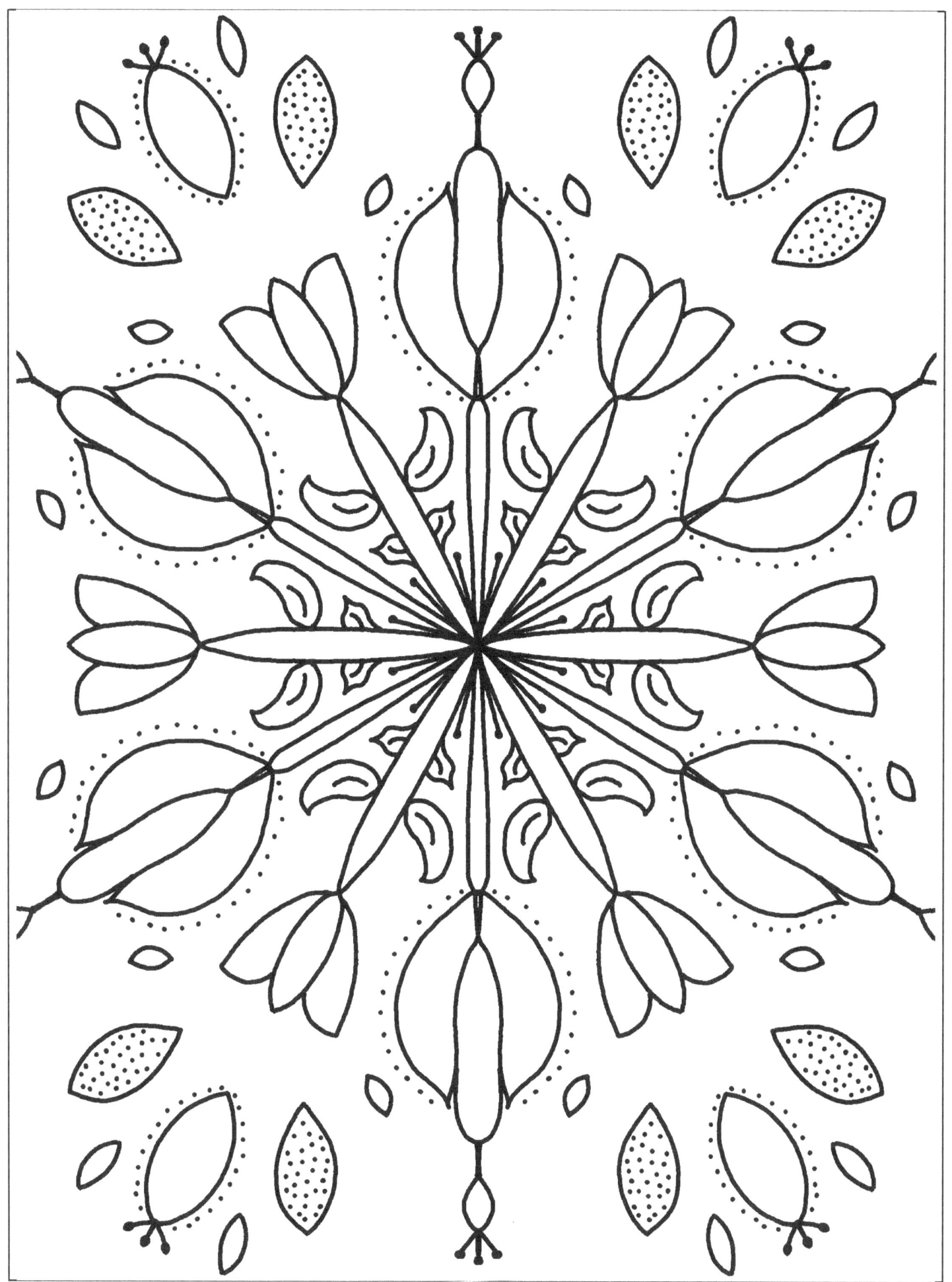

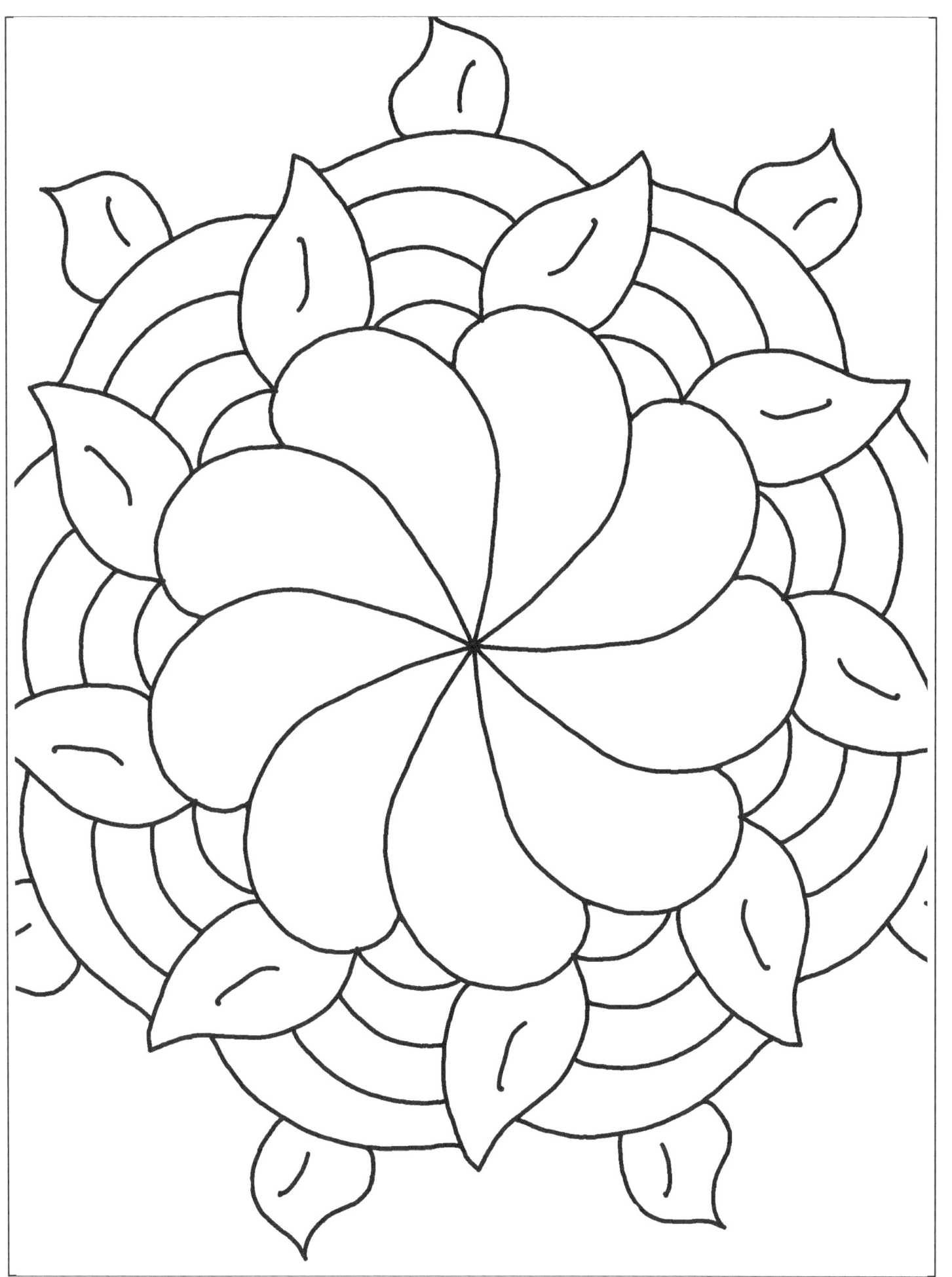

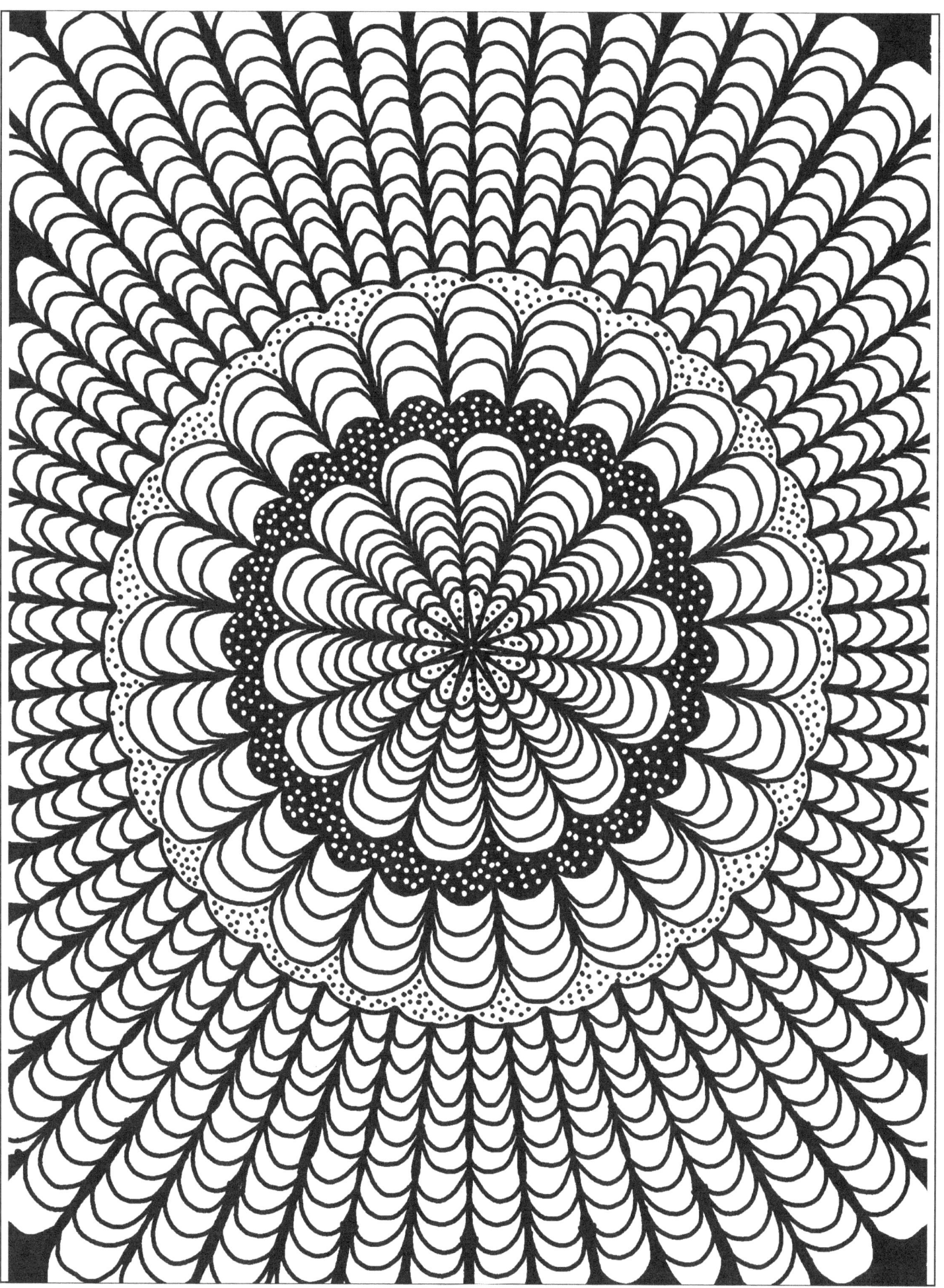

About The Artist

Terry McClary

Terry McClary is an artist with two decades of professional experience working in a variety of media including illustration, painting, sculpting, graphic design, and fine art photography.

If you are interested in downloading free coloring pages to print or color digitally or in watching Terry's videos and tutorials please visit her website!

terrymcclary.com

Coloring Tool Test

www.ingramcontent.com/pod-product-compliance
Lightning Source LLC
Chambersburg PA
CBHW081253180526
45170CB00007B/2404